Stained Glass
Coloring Book
Nature and Landscapes

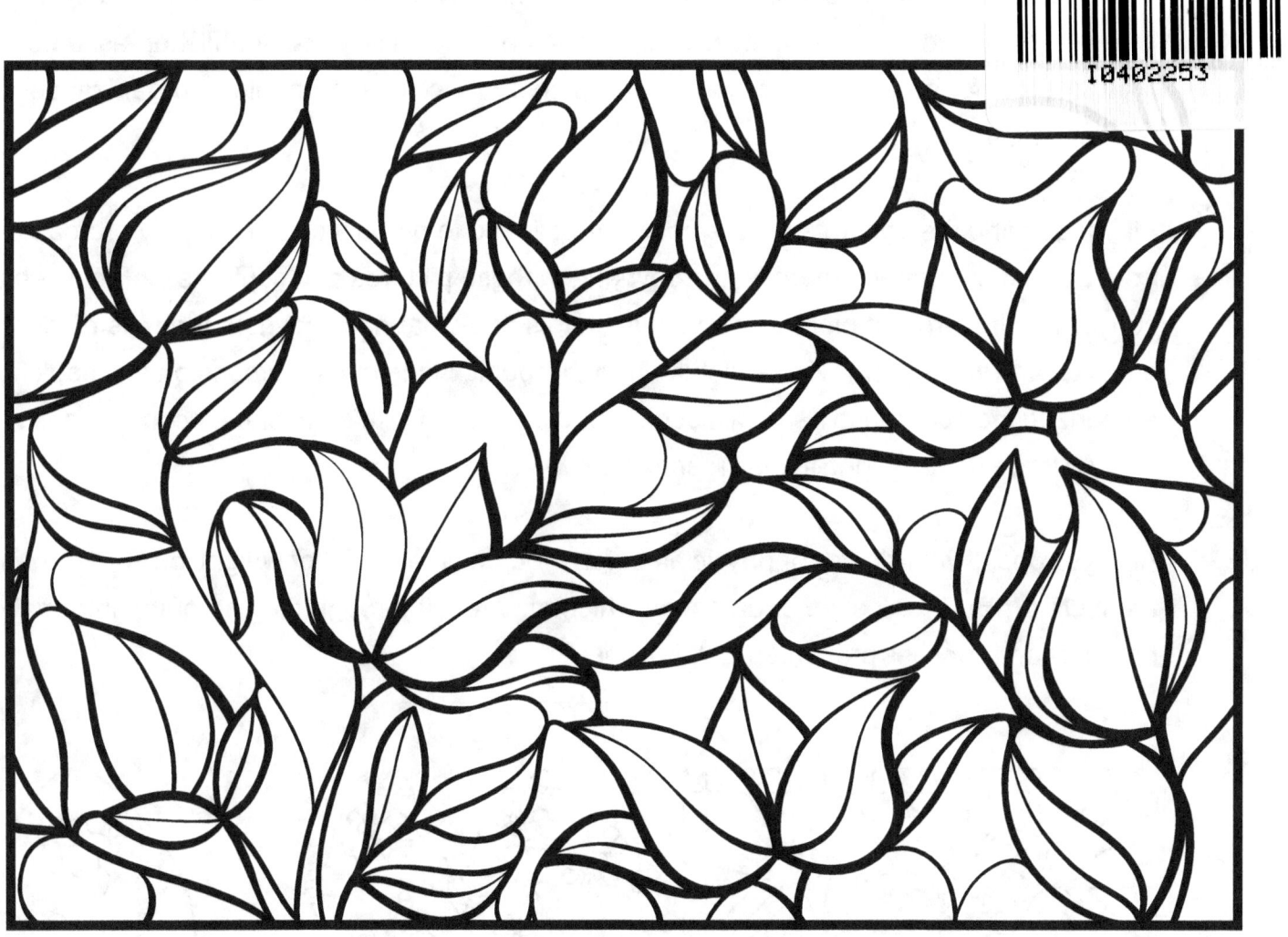

By Alpa Rationalist
Alpa Rationalist © 2019.

Copyright Notice

No part of this book may be reproduced or transmitted in any form whatsoever, electronic, or mechanical including photocopying, recording or by any informational storage and retrieval system without the express written dated and signed permission of the author.
Disclaimer/ and or Legal Notice.

The information presented herein represents the view of the author as of the date of publication. Because of the rate with which conditions change, the author reserves the right to alter and update his opinions based on new conditions.

This book is for informational purposes only. While every attempt was made to verify the information provided here, neither the author nor his affiliates or publisher assume any responsibility for errors inaccuracies or omissions. Any slights to people or organizations are unintentional.

All images and the contents on this book are believed to be public domain, they are gathered from all over the net and there is no copyright on these pictures and contents as far as we are concerned. If there is a picture or contents on this book that has copyright then the owner can email us and we will remove the picture from this book. None of the persons on this book have authorized their presence here, this book is not associated with them or their companies in any way. All trademarks belong to their respective owners.

Always consult your doctor or physician before you begin any diet or weight loss program. We are NOT LIABLE for losses or damages which may result through the use of the information, products and services presented on this Book.

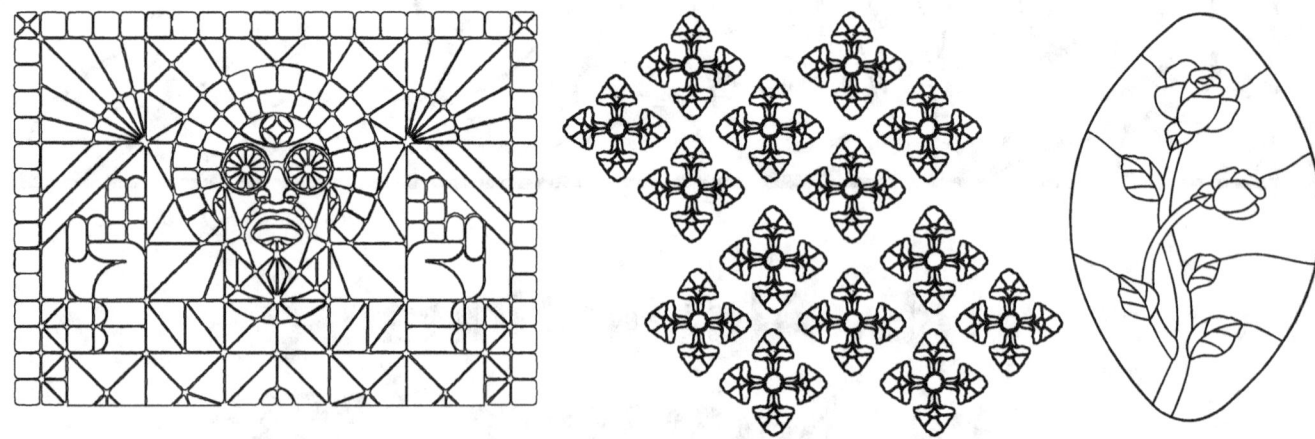

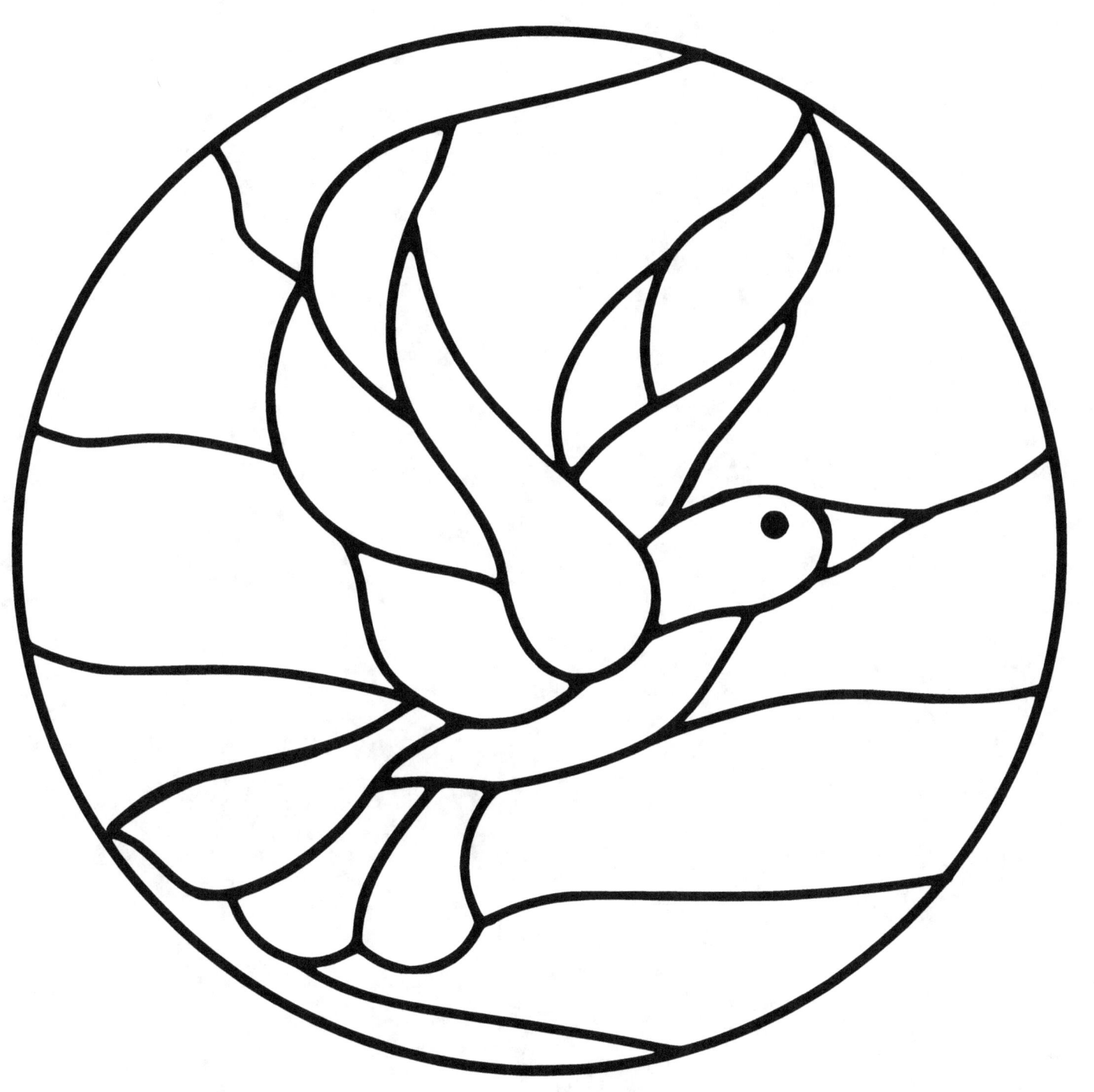

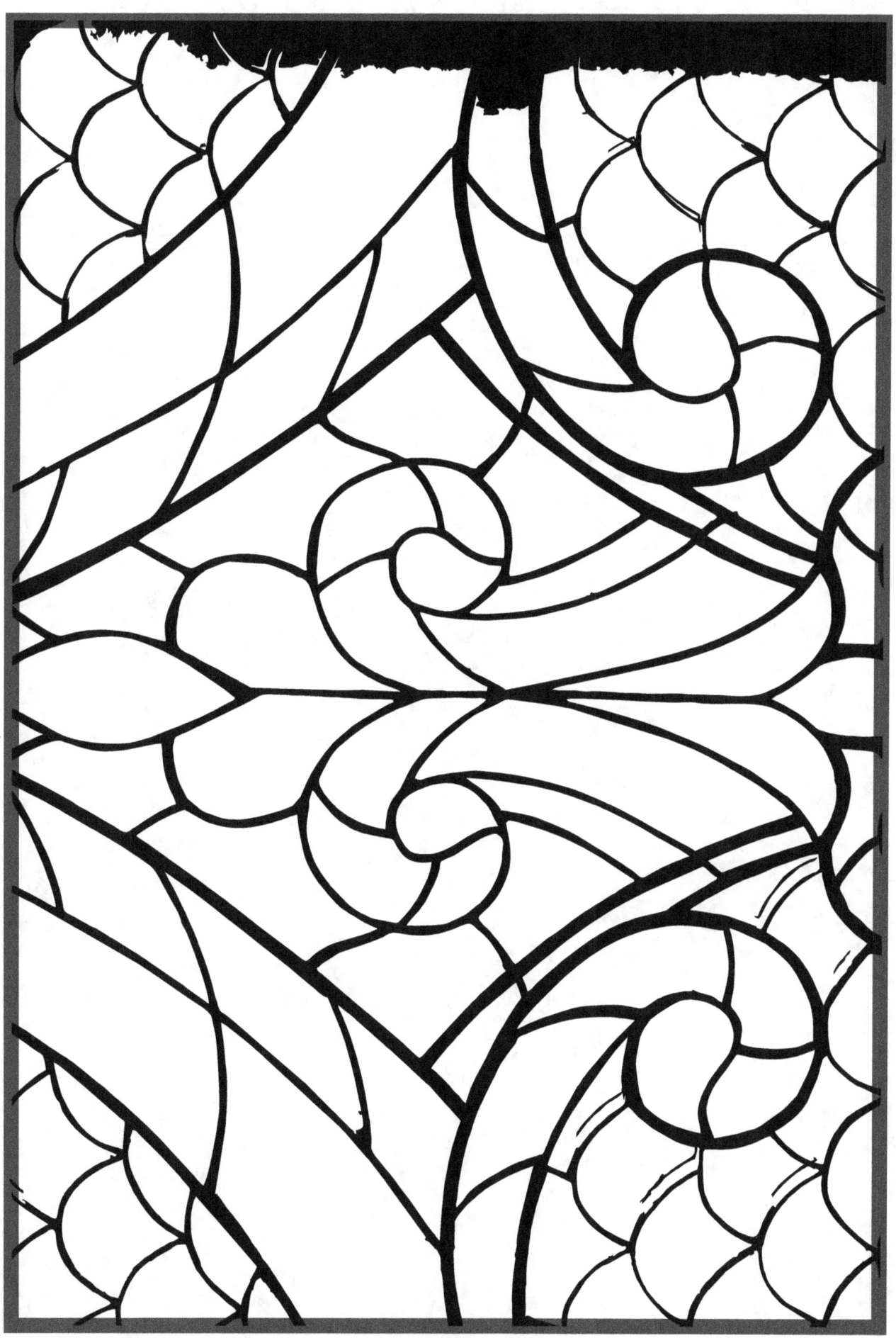

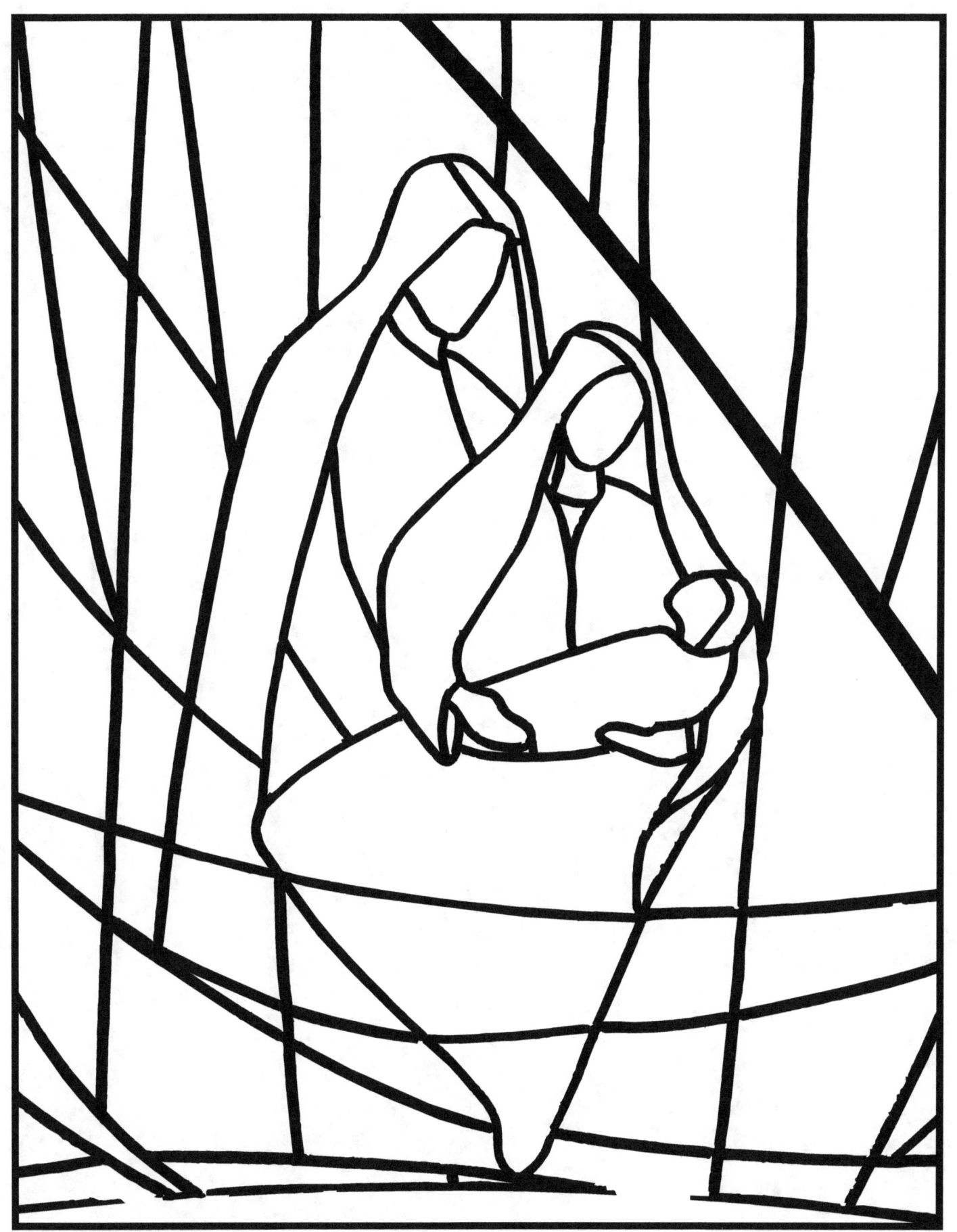

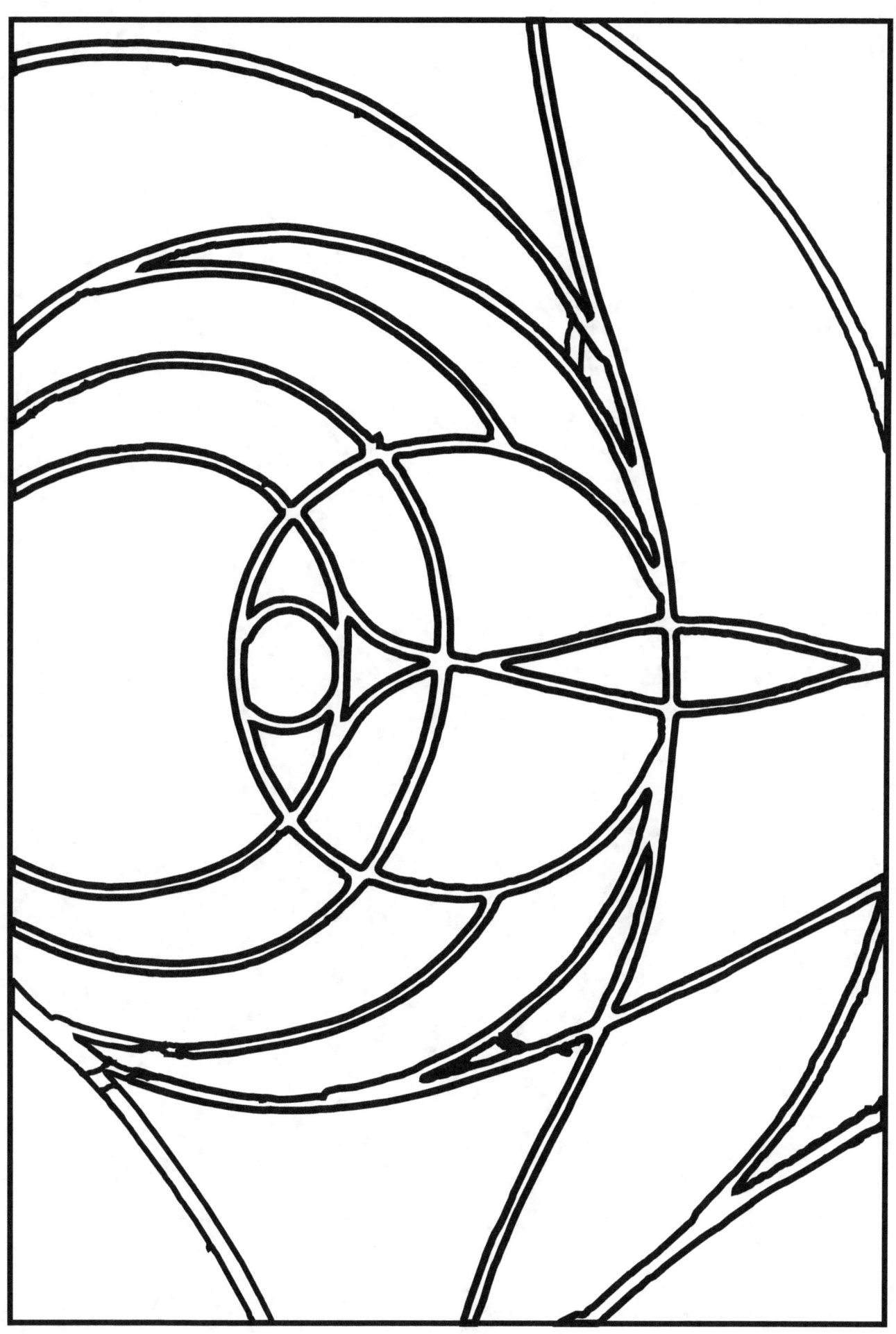

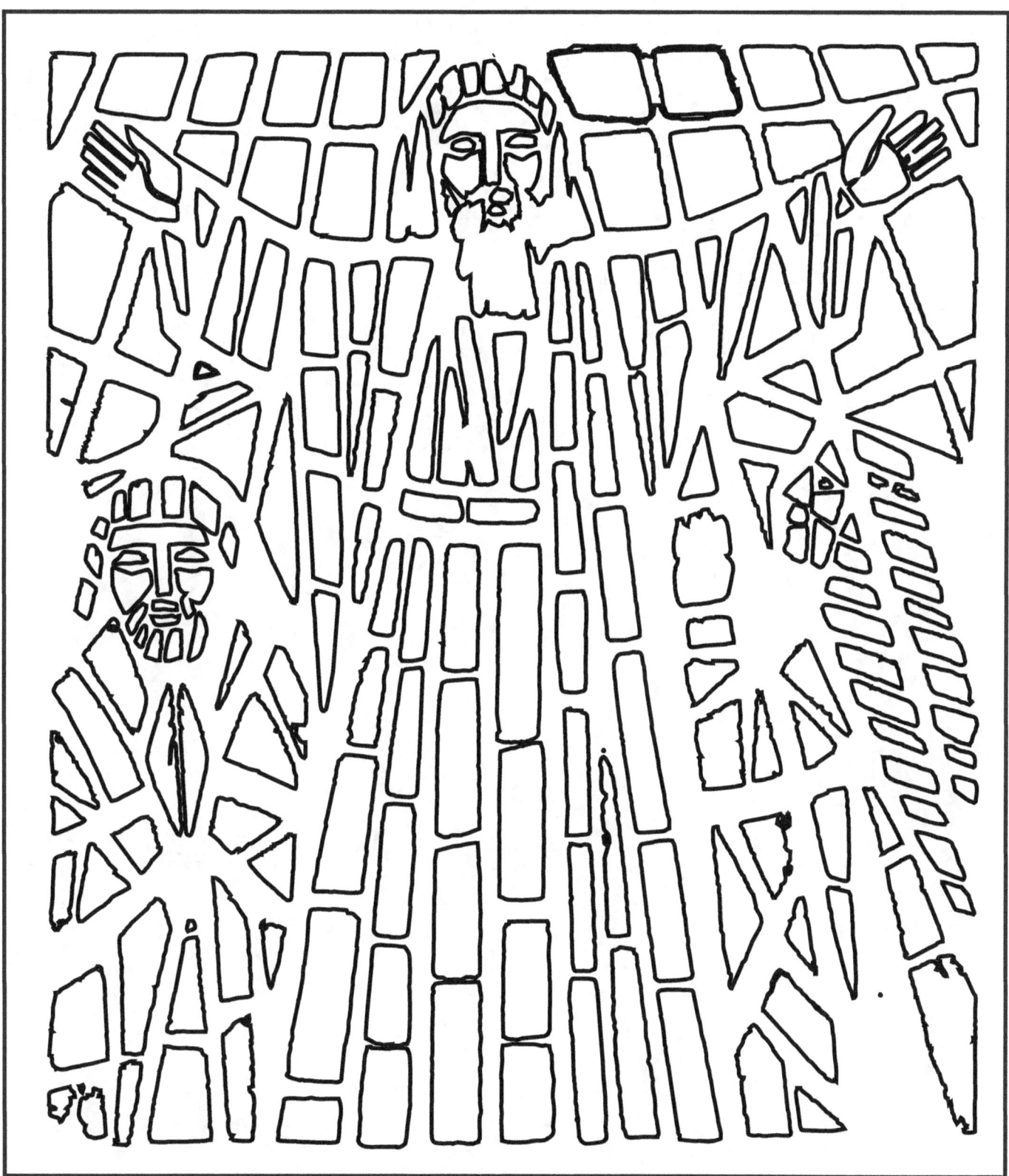

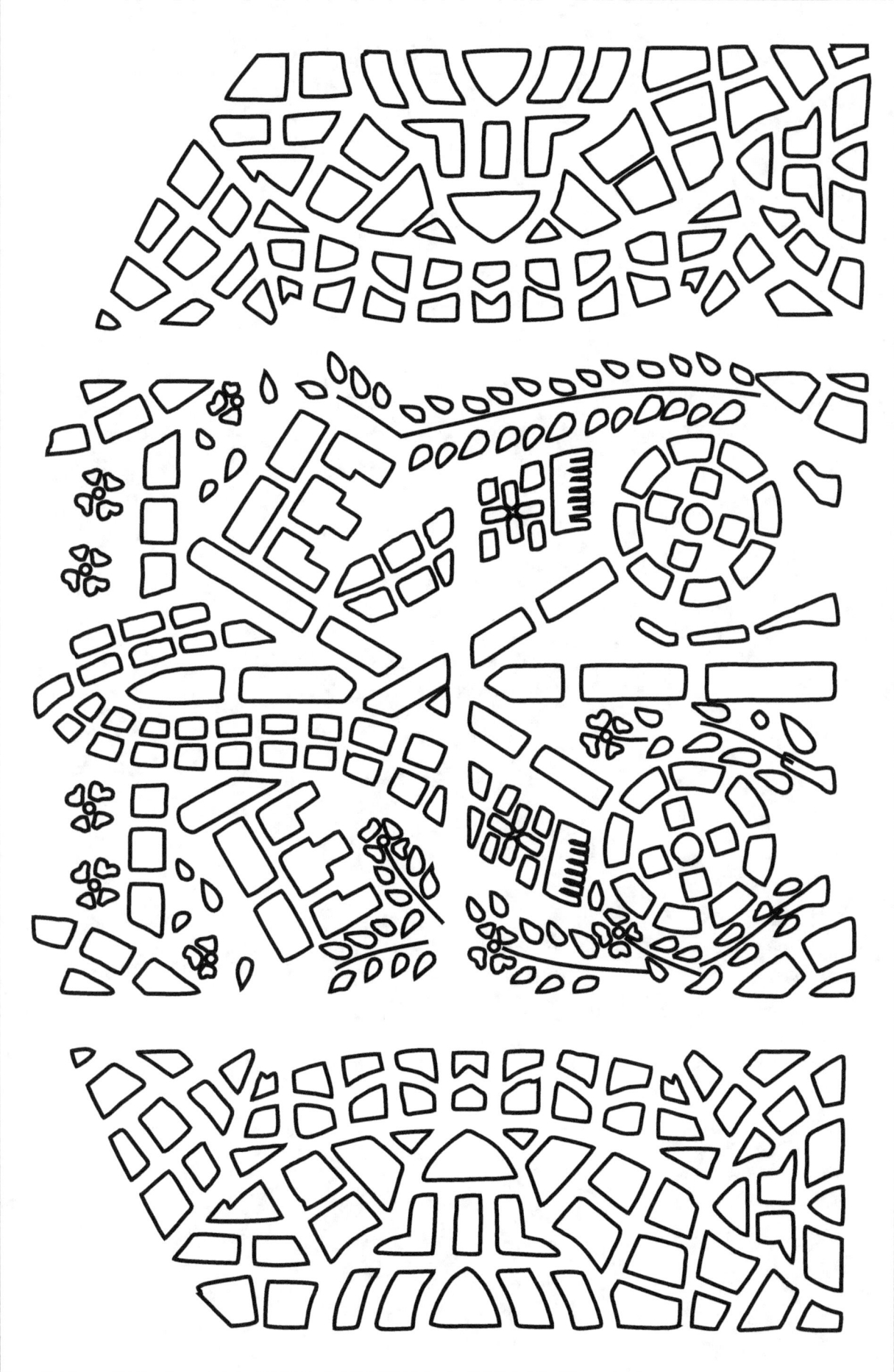

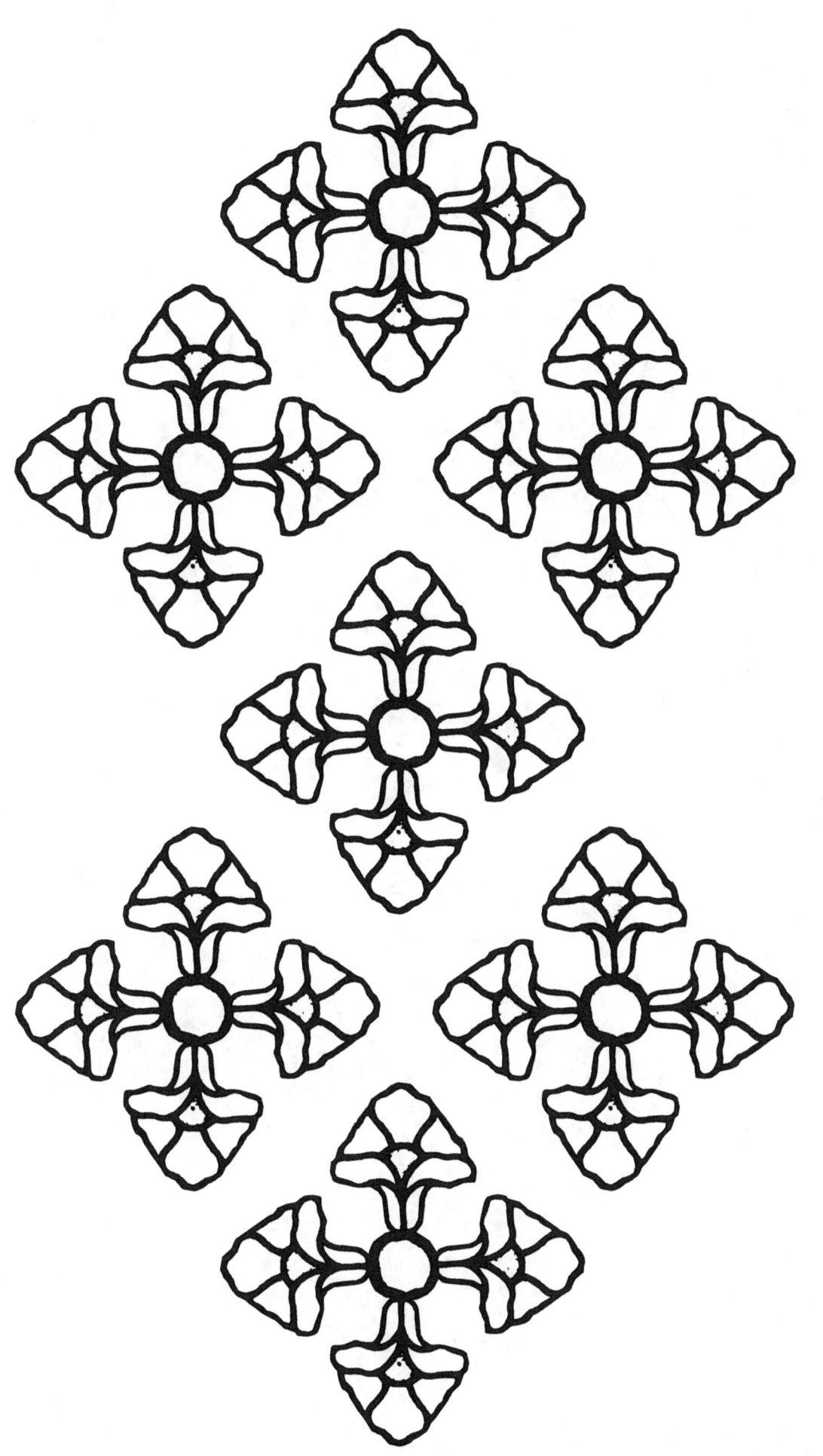

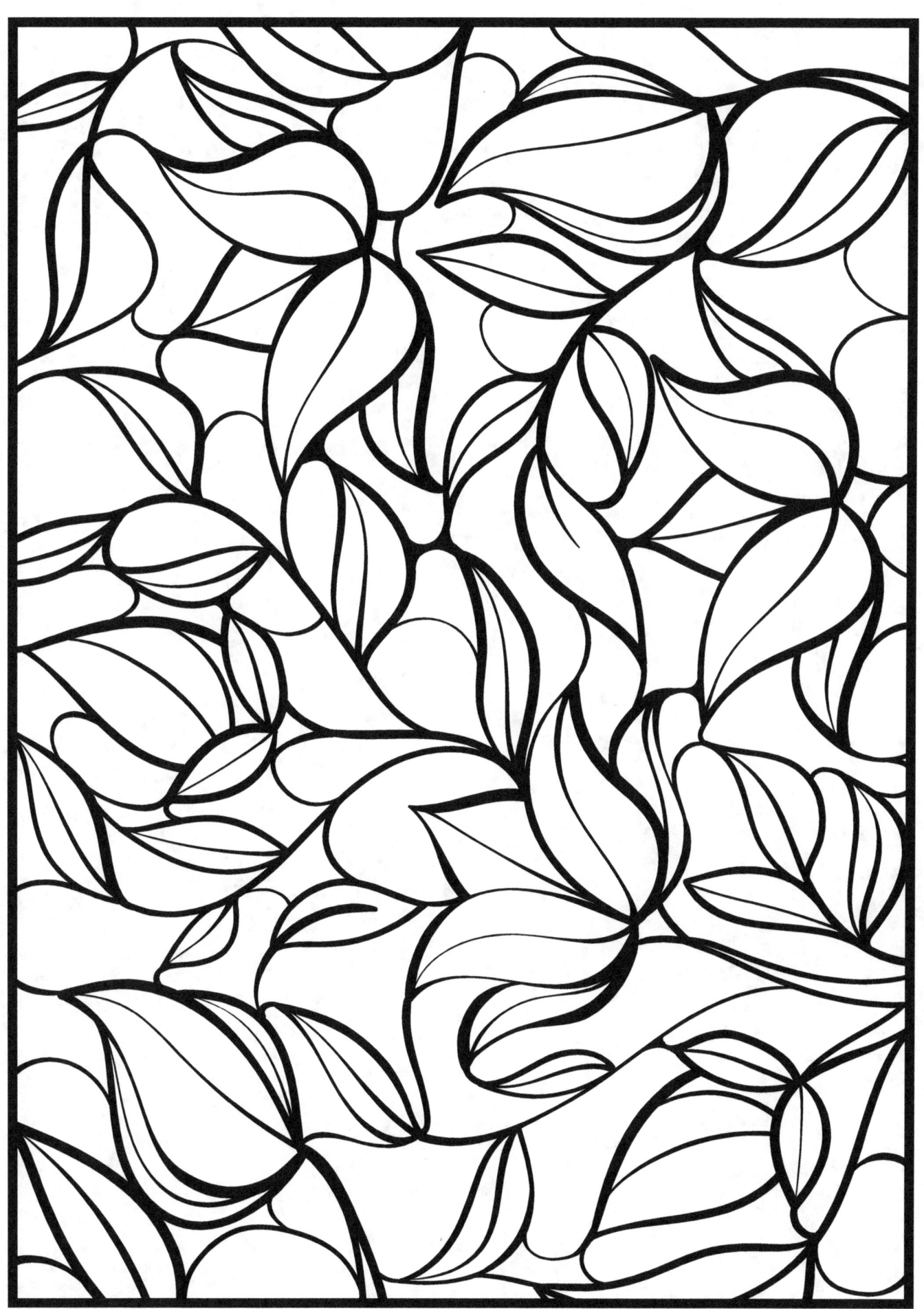

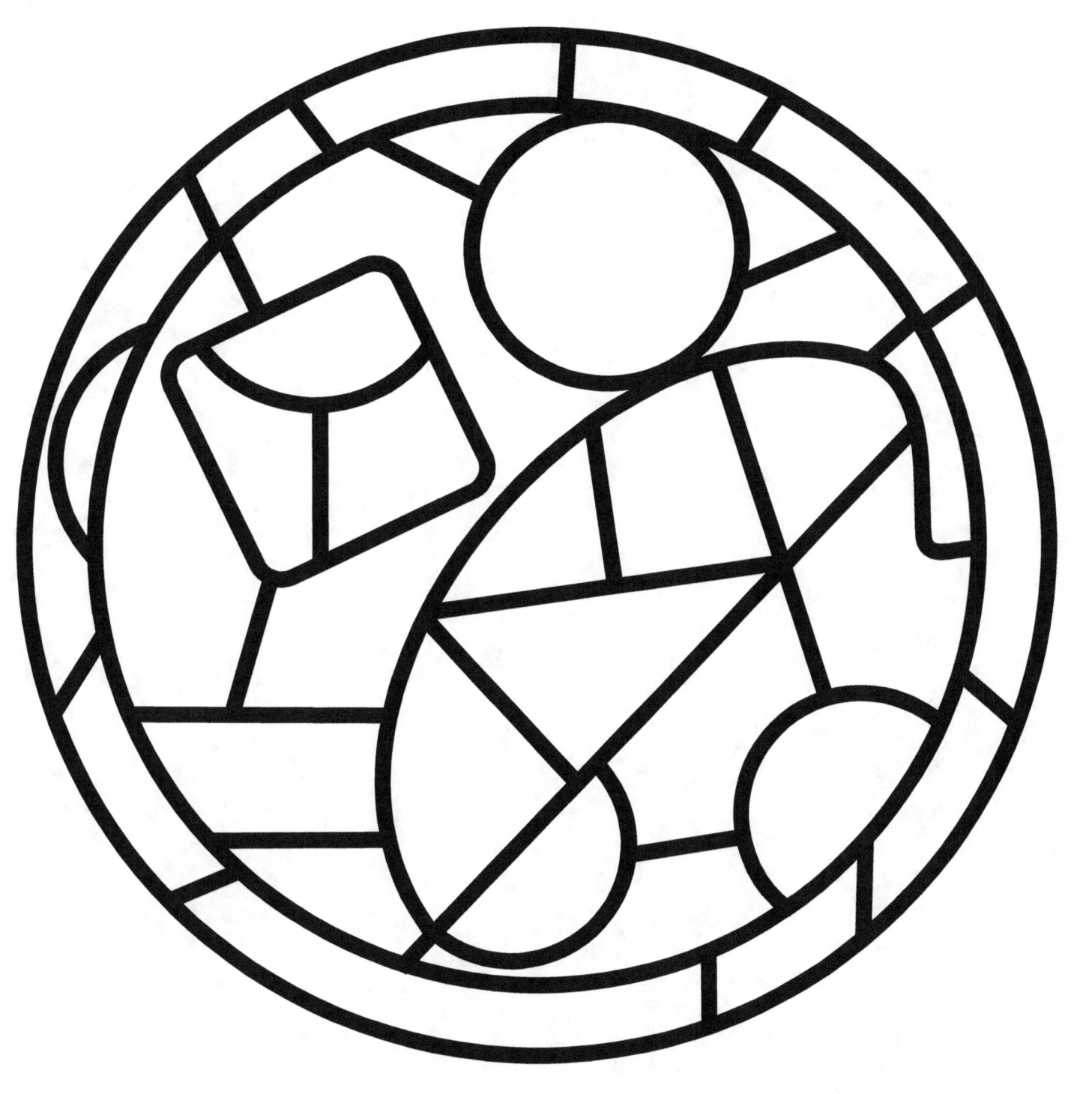

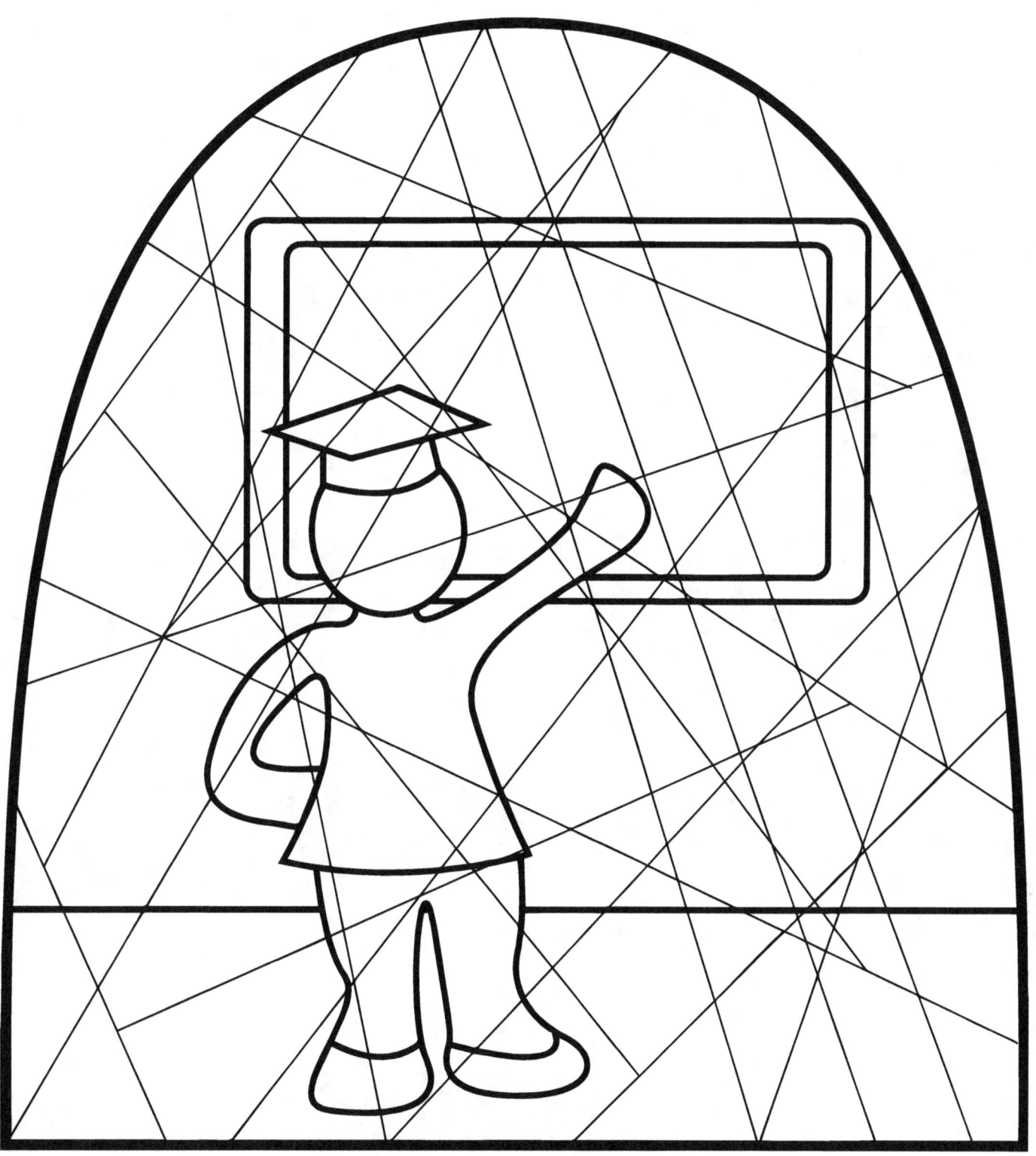

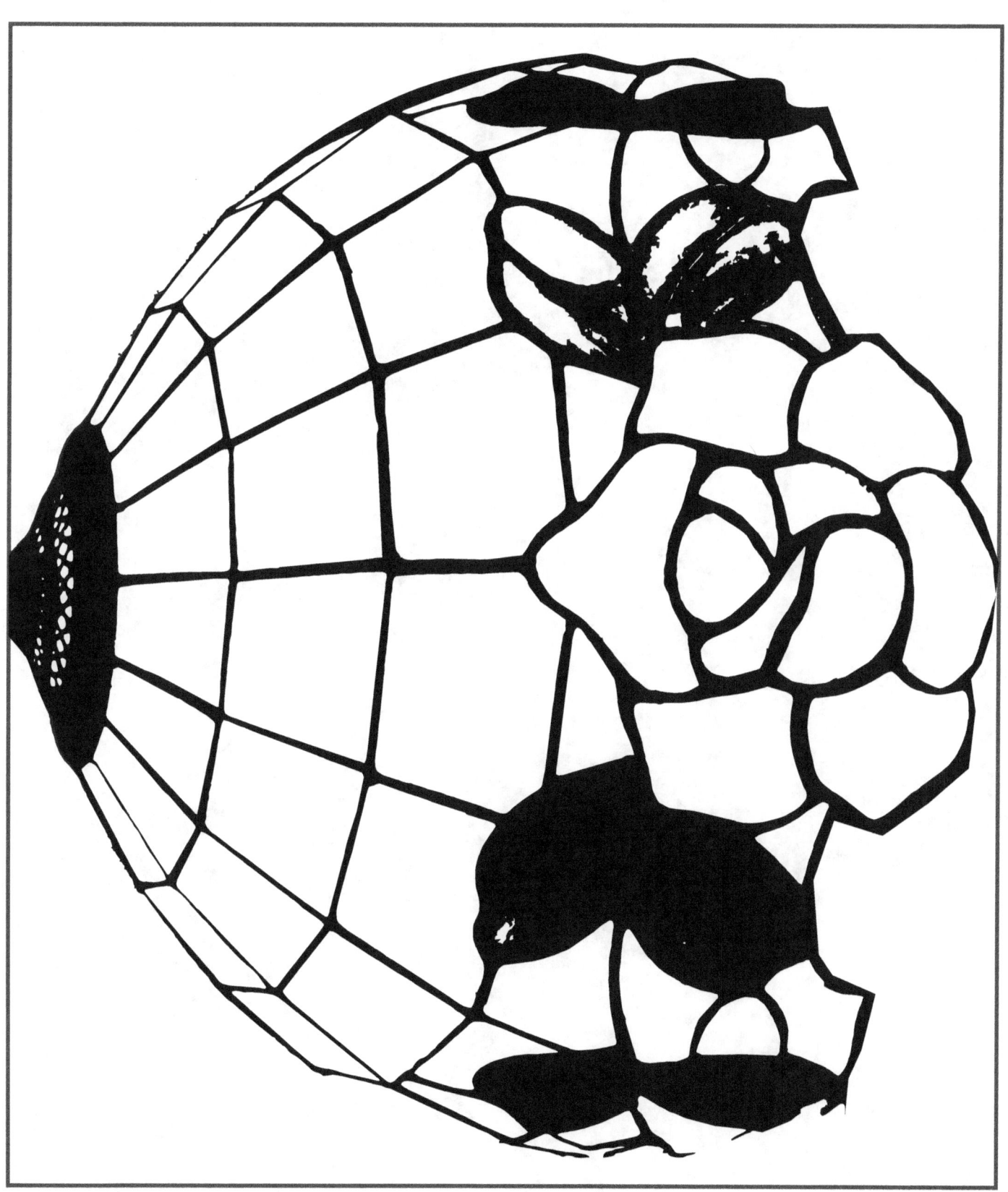

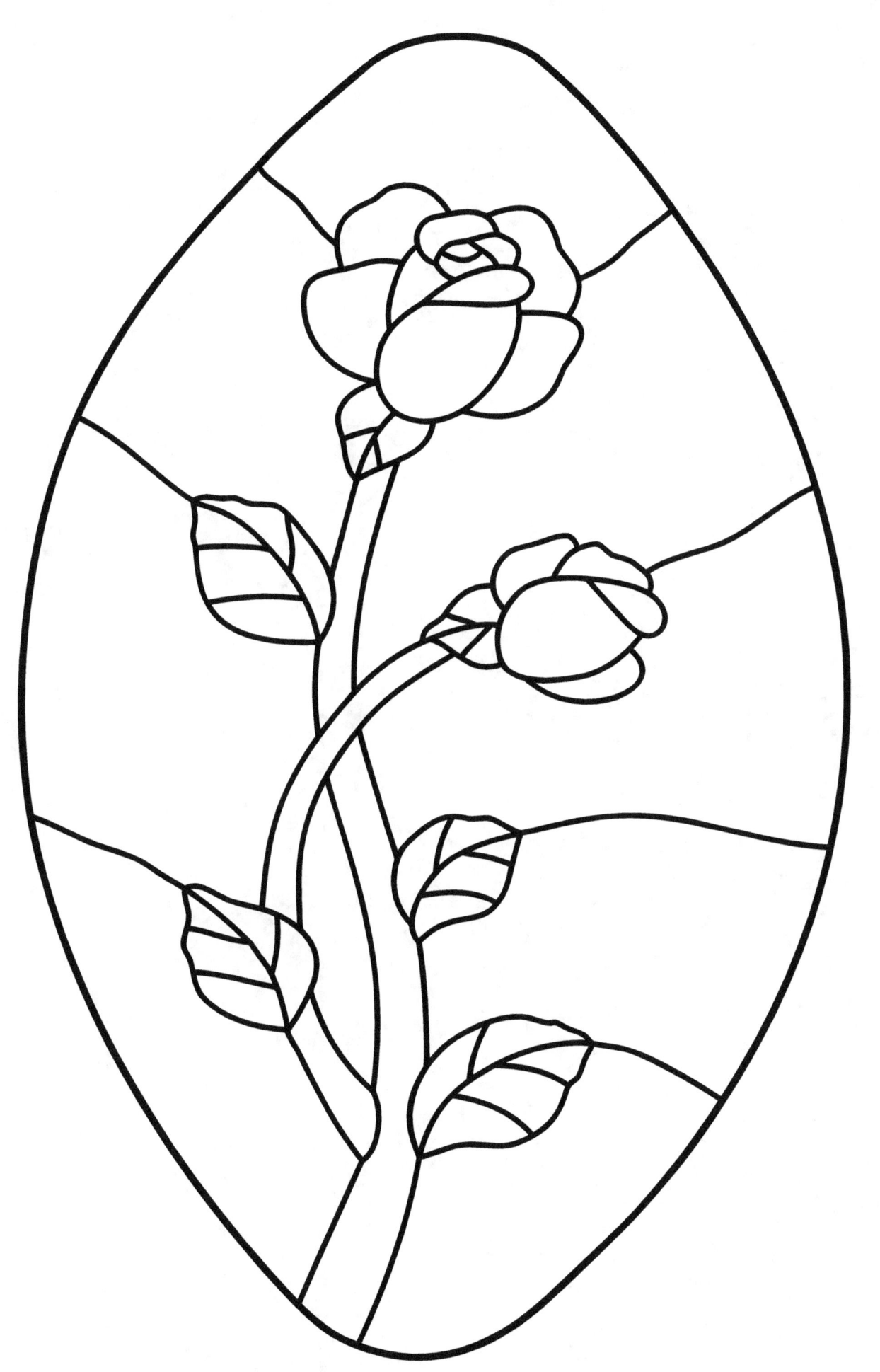

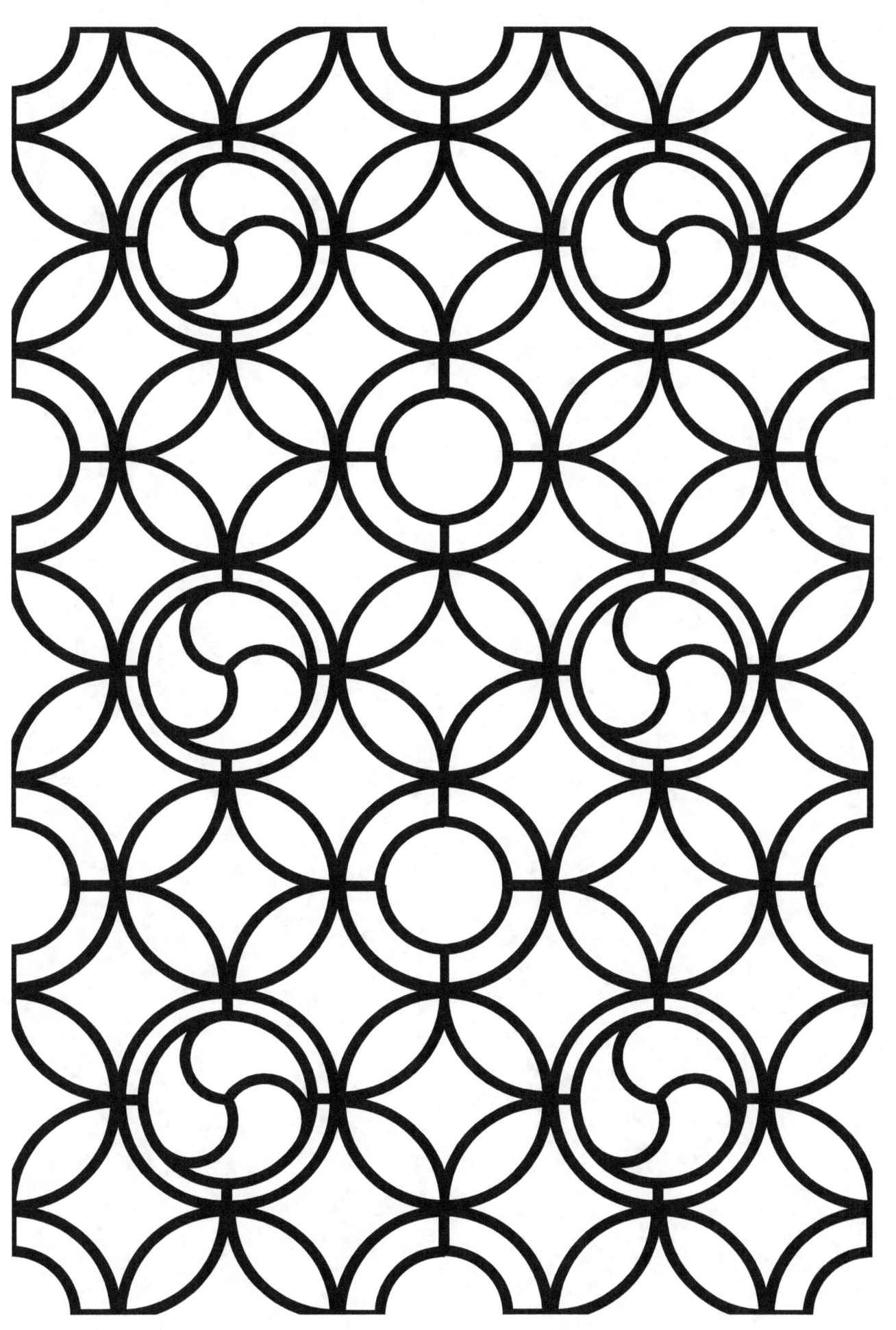

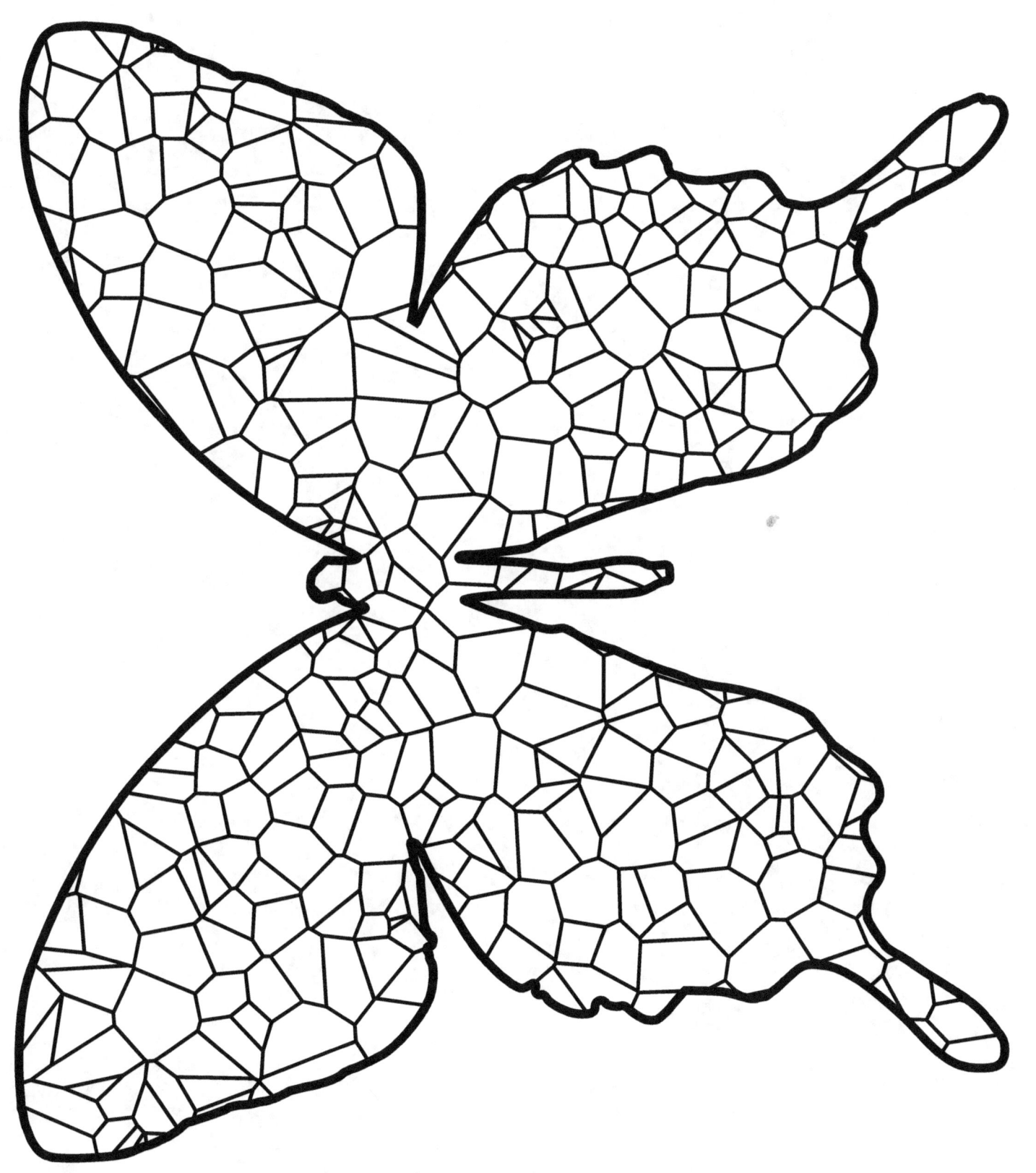

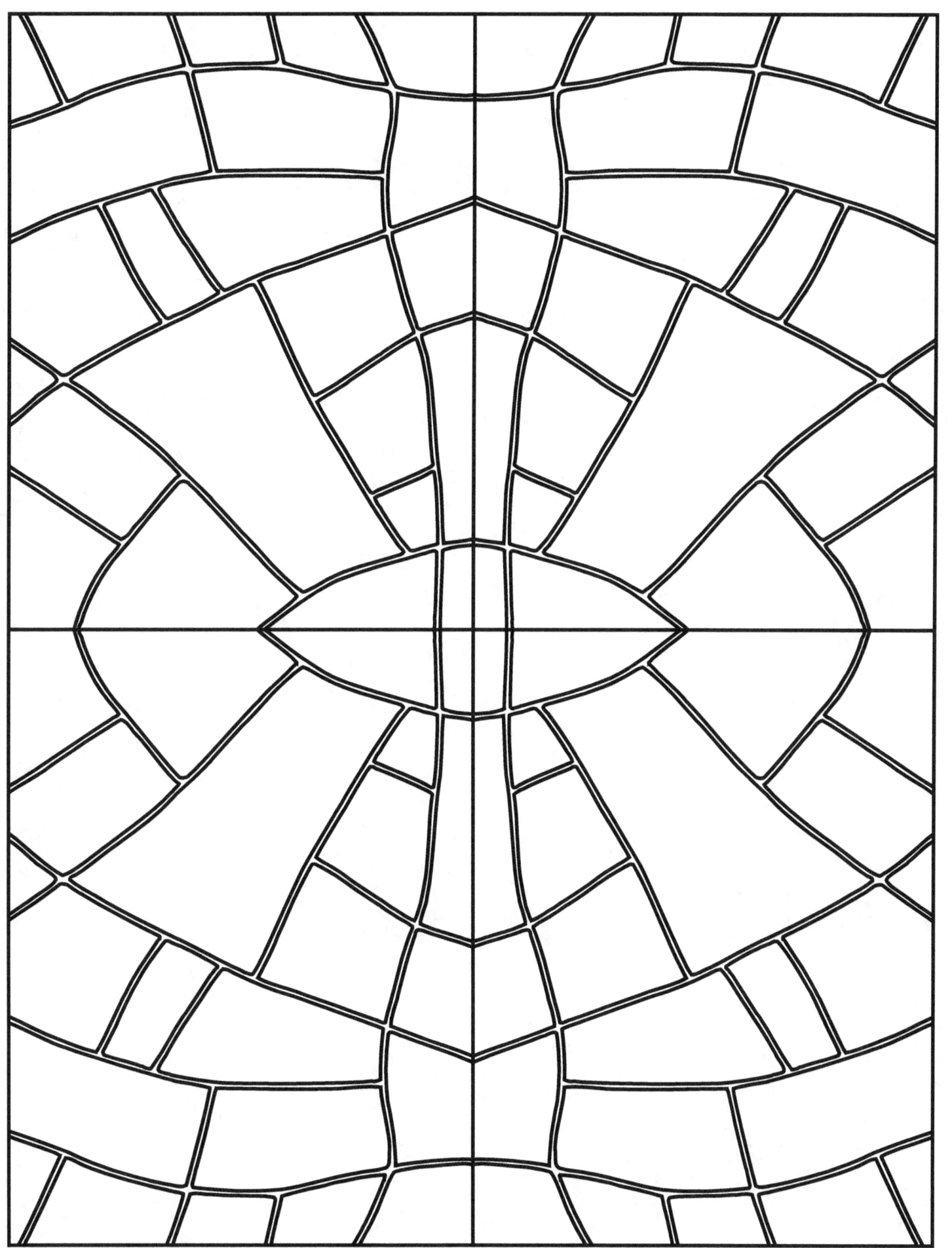

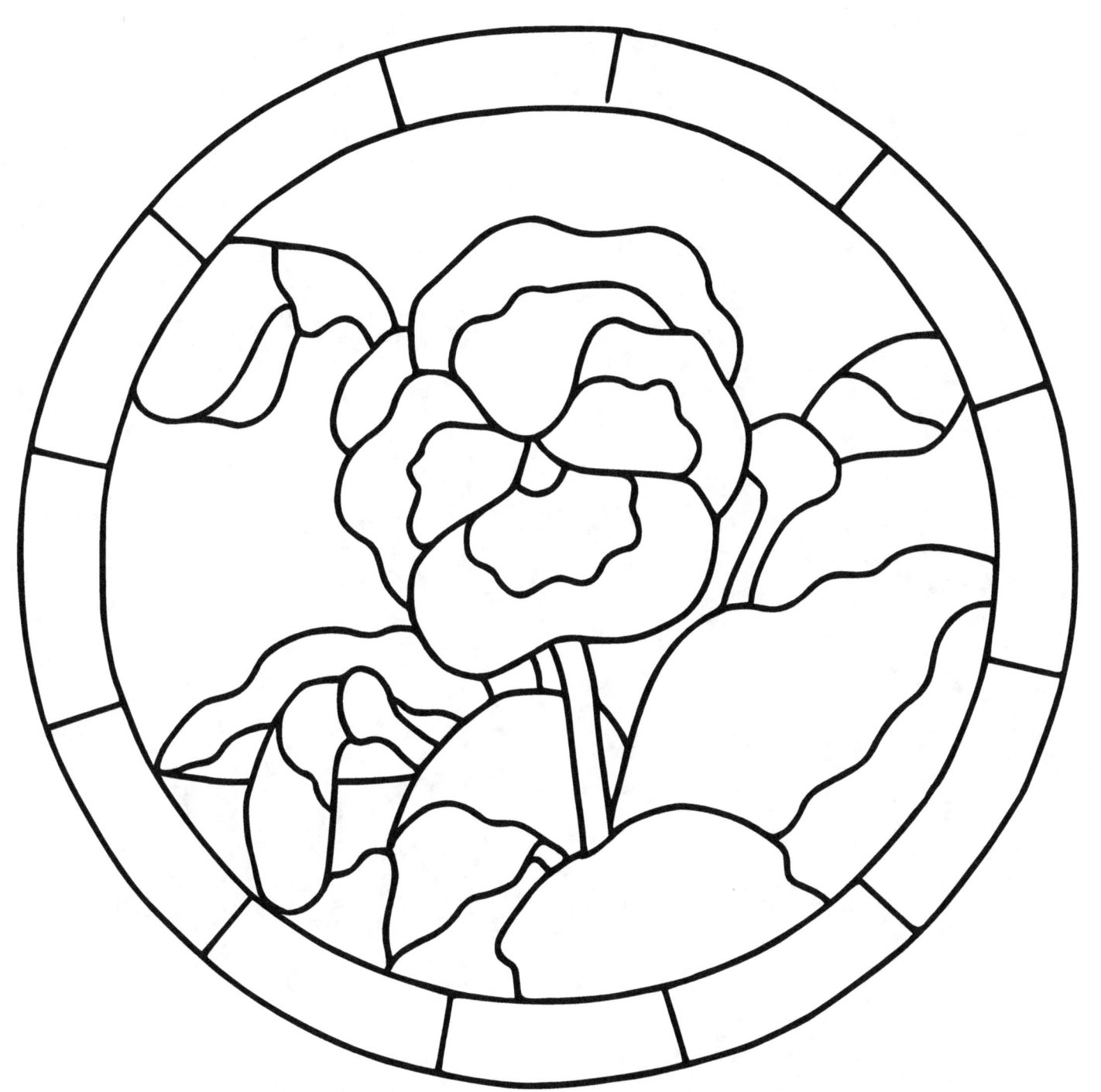

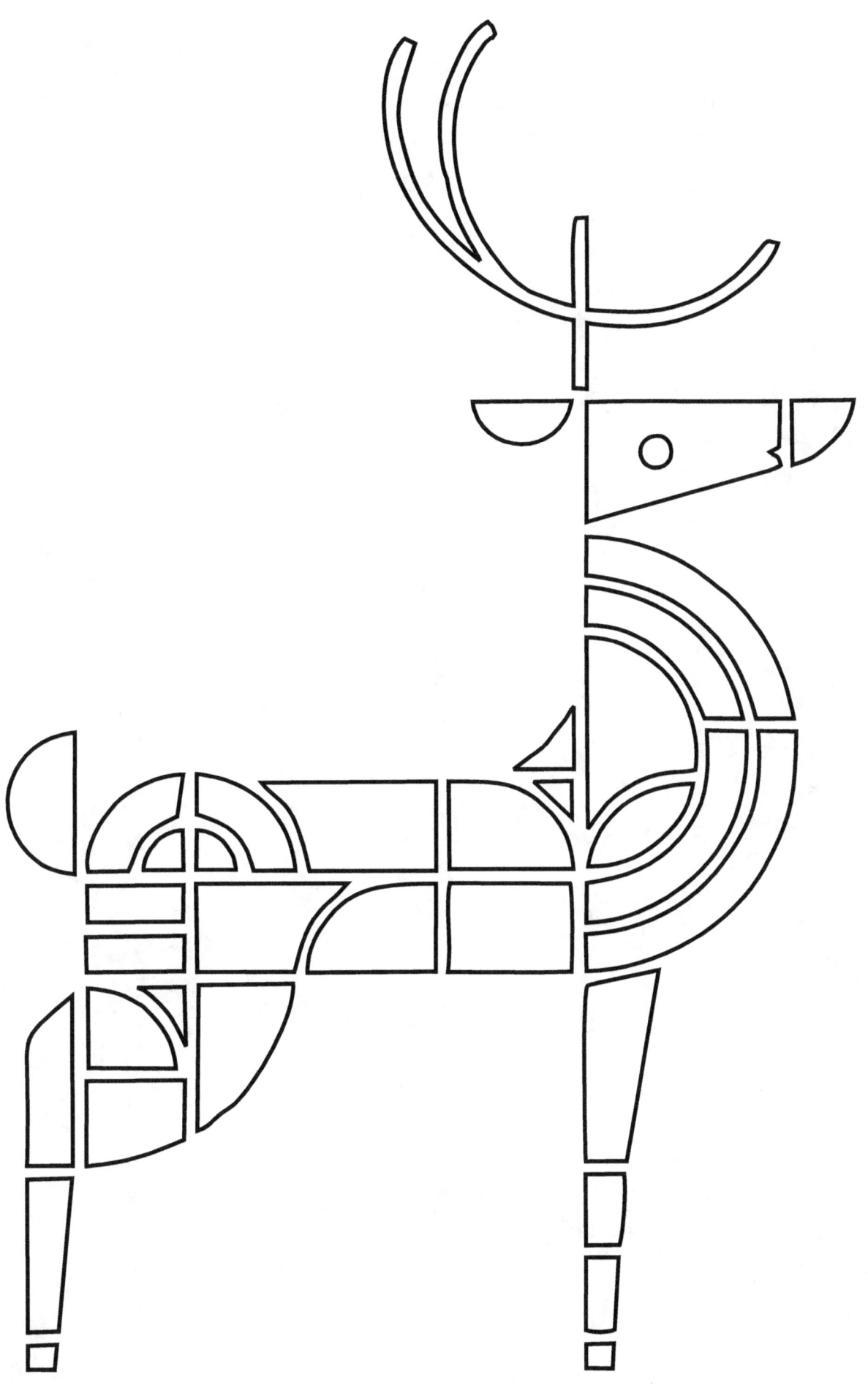

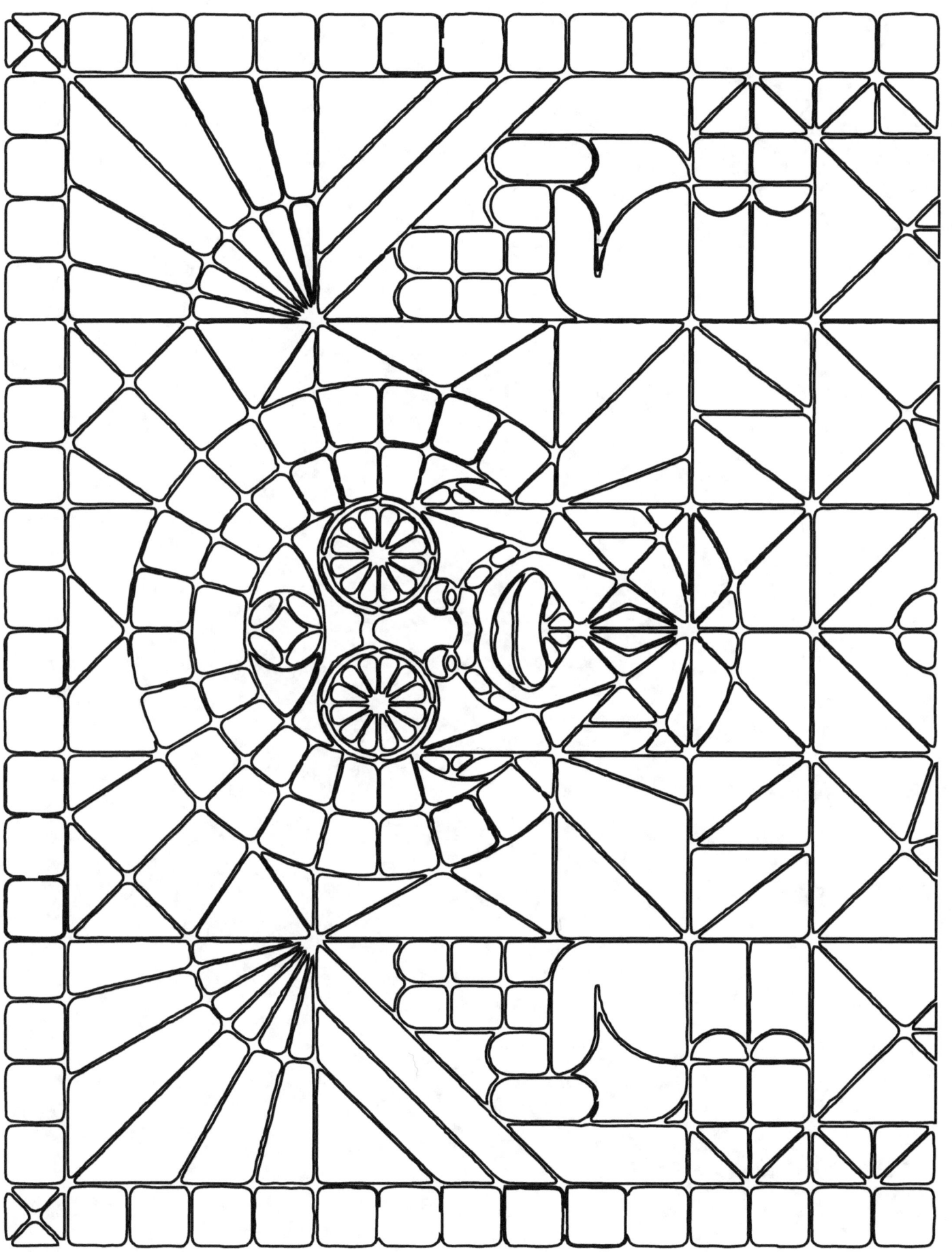

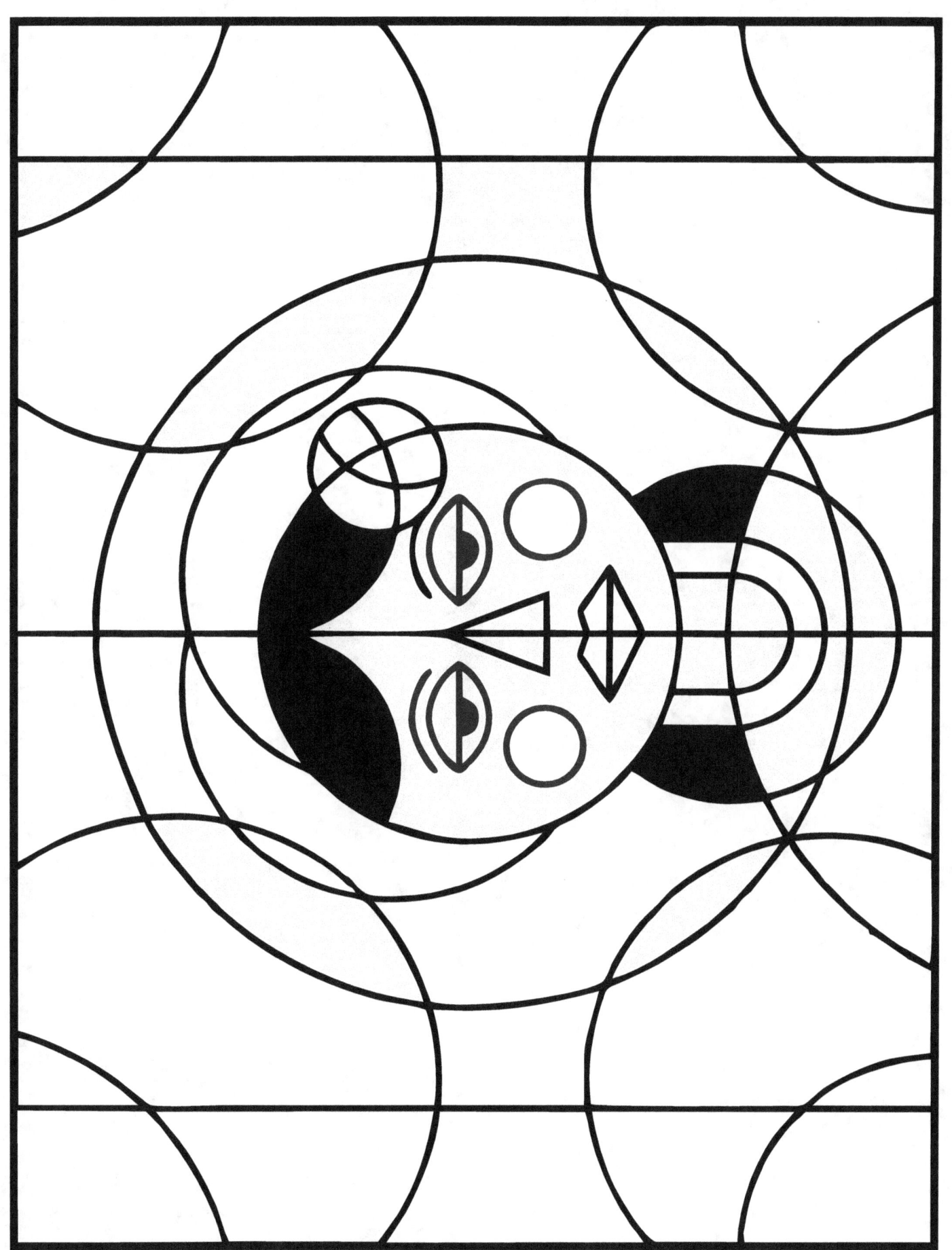

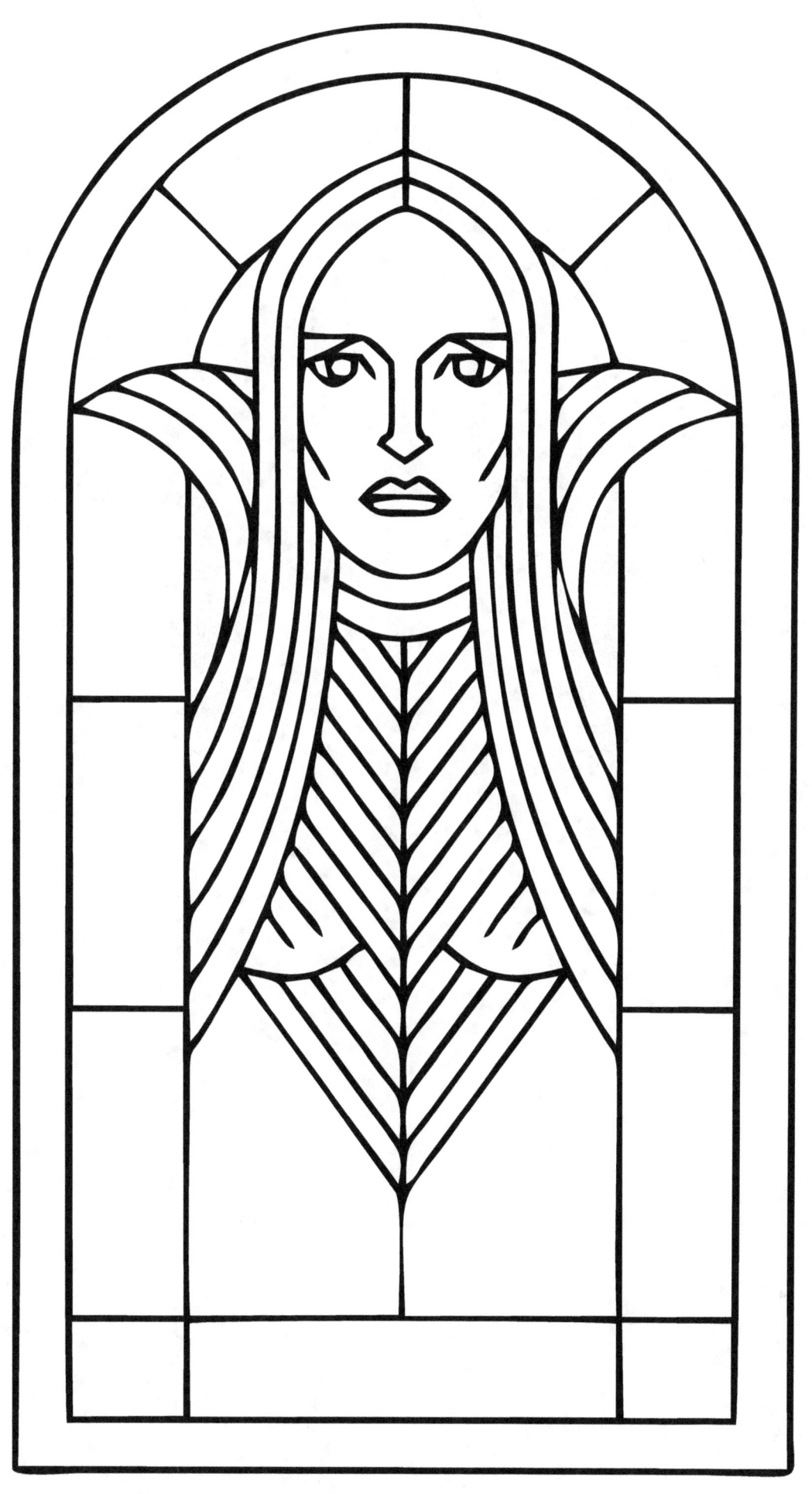

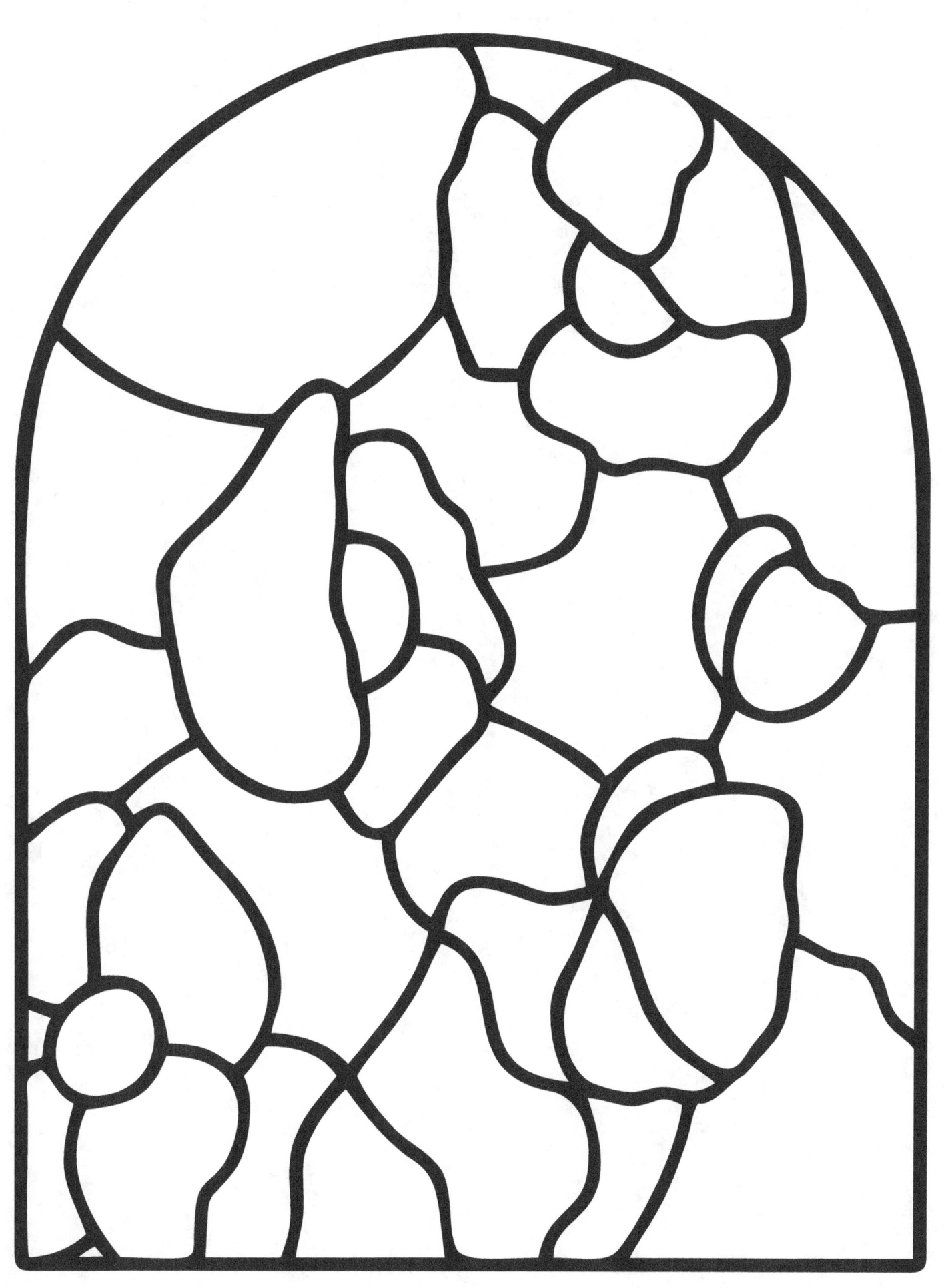

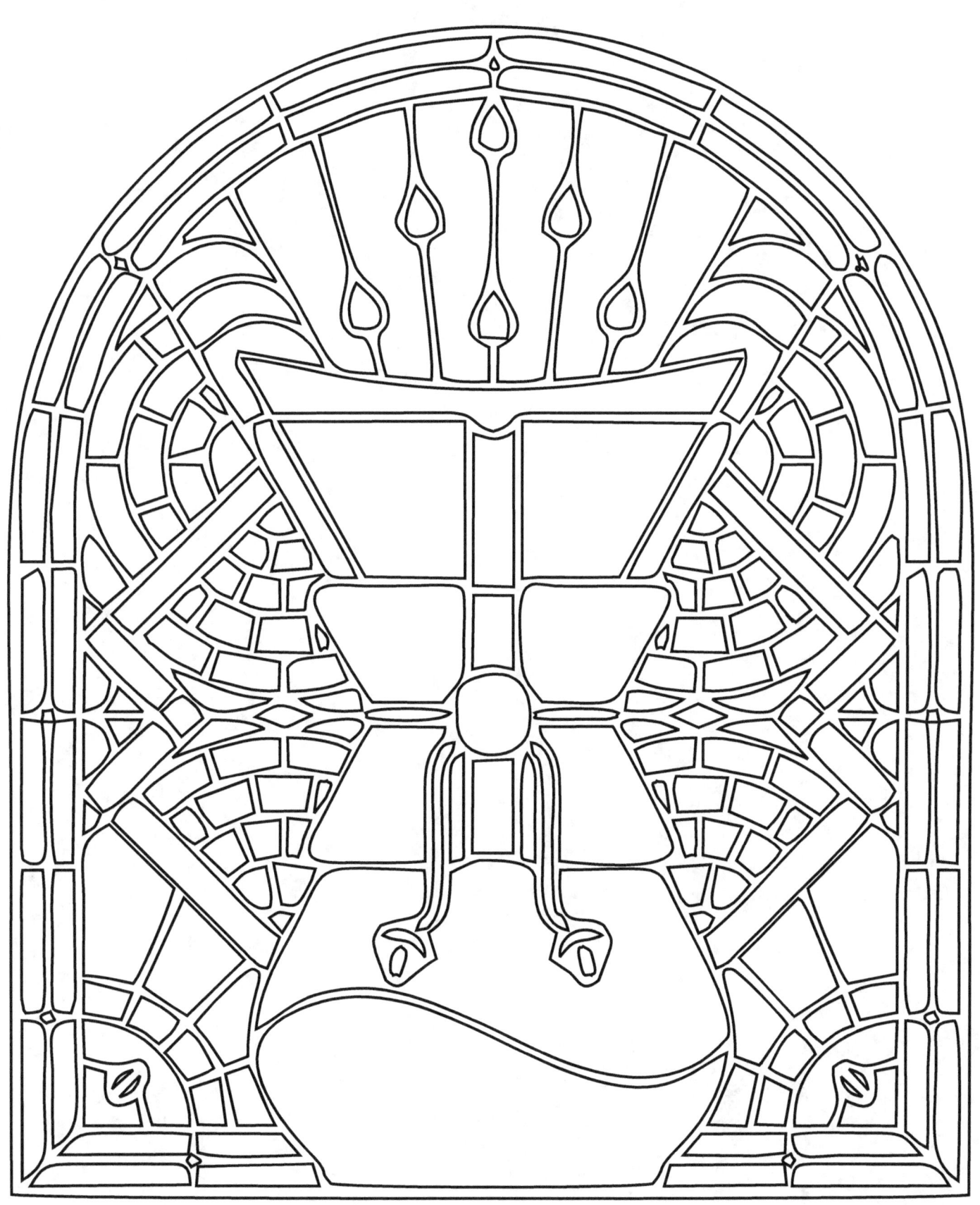

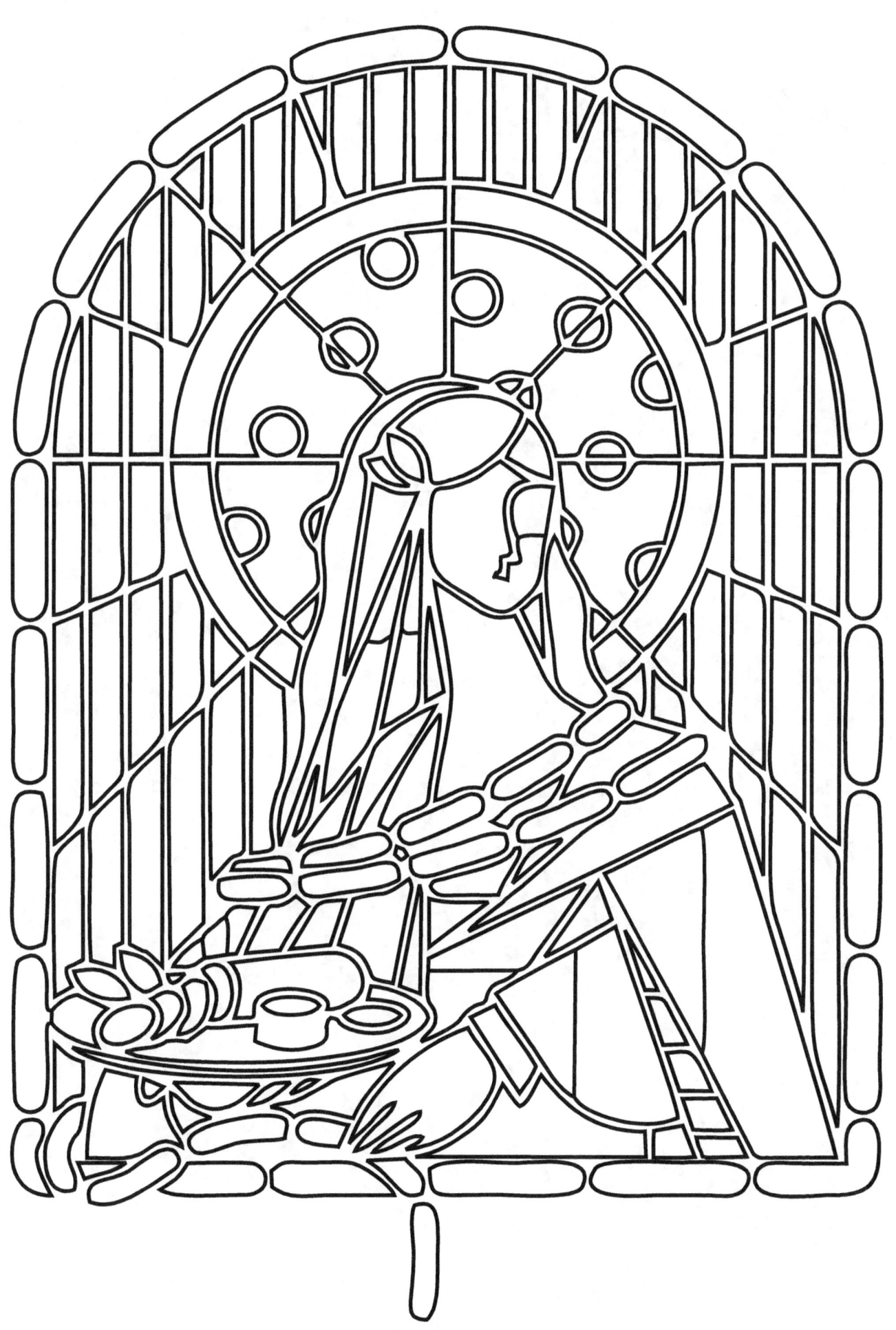

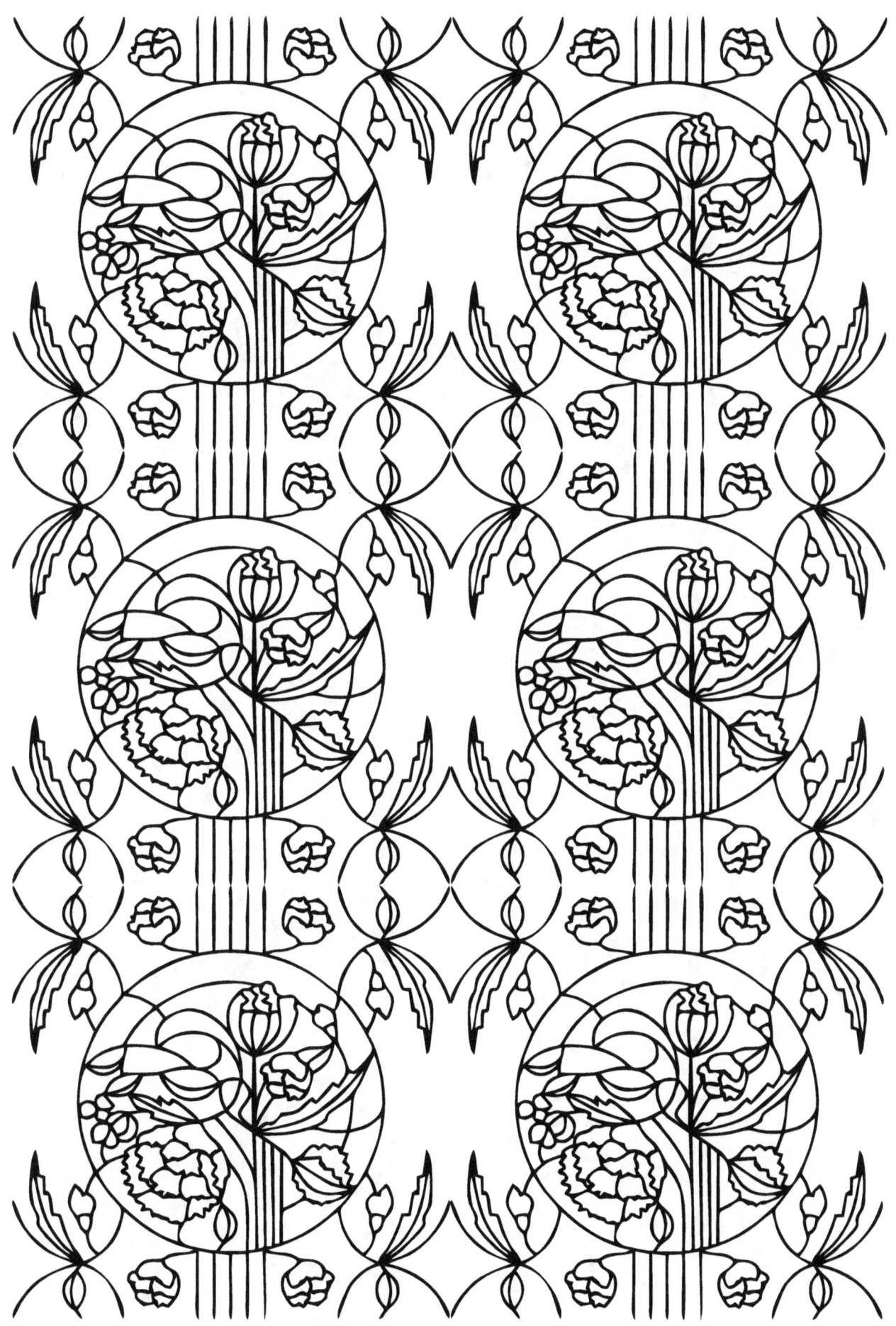

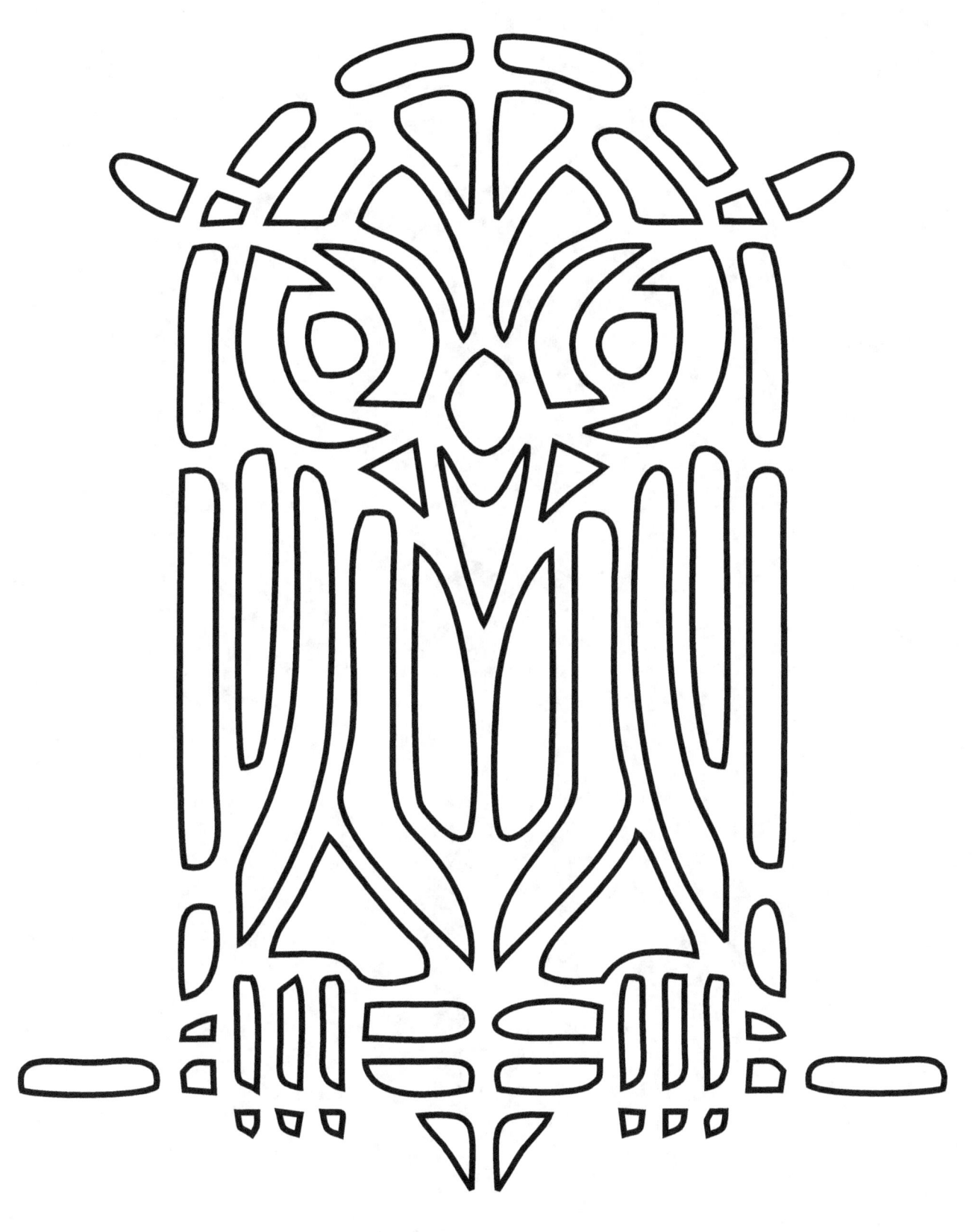

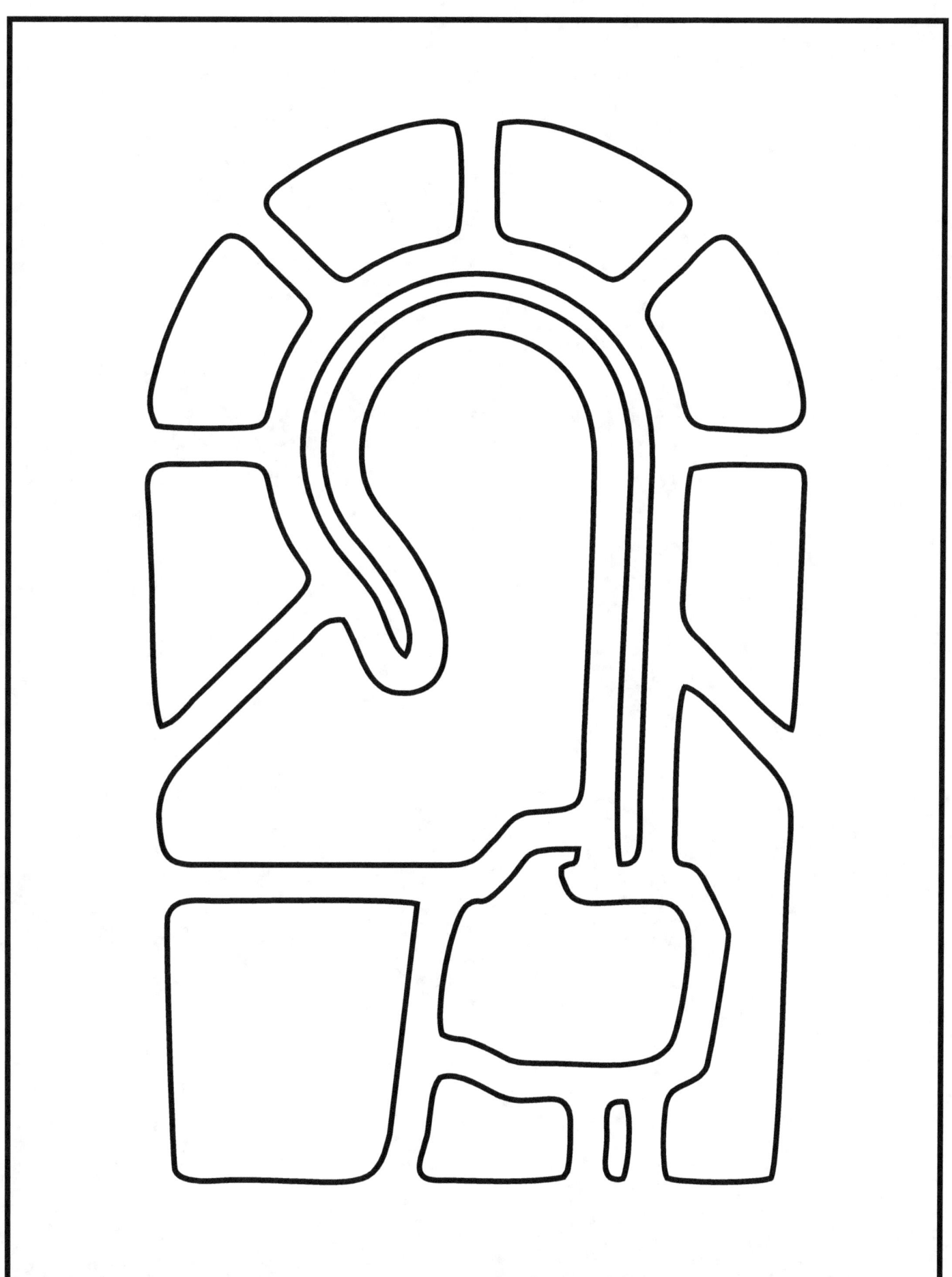

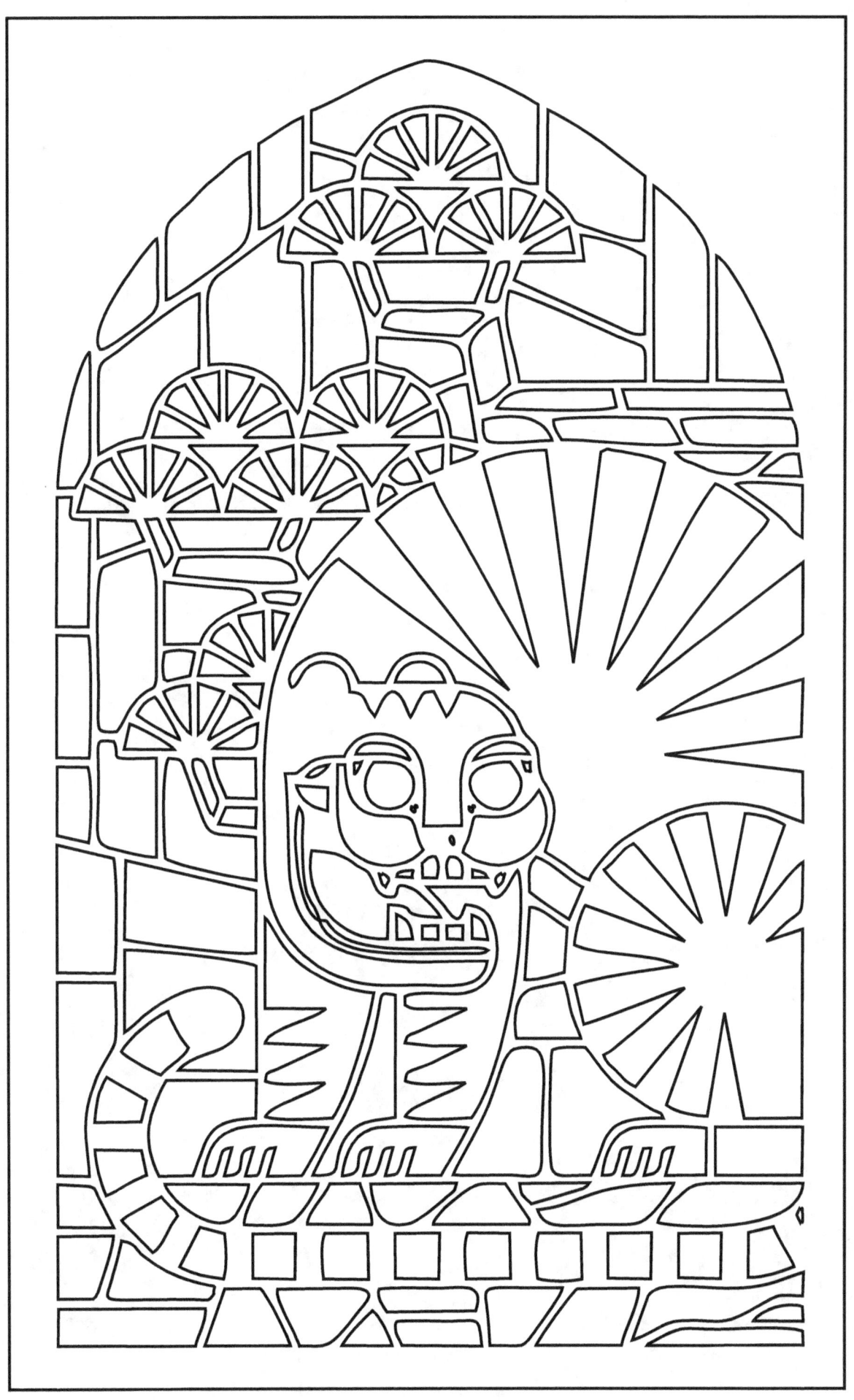

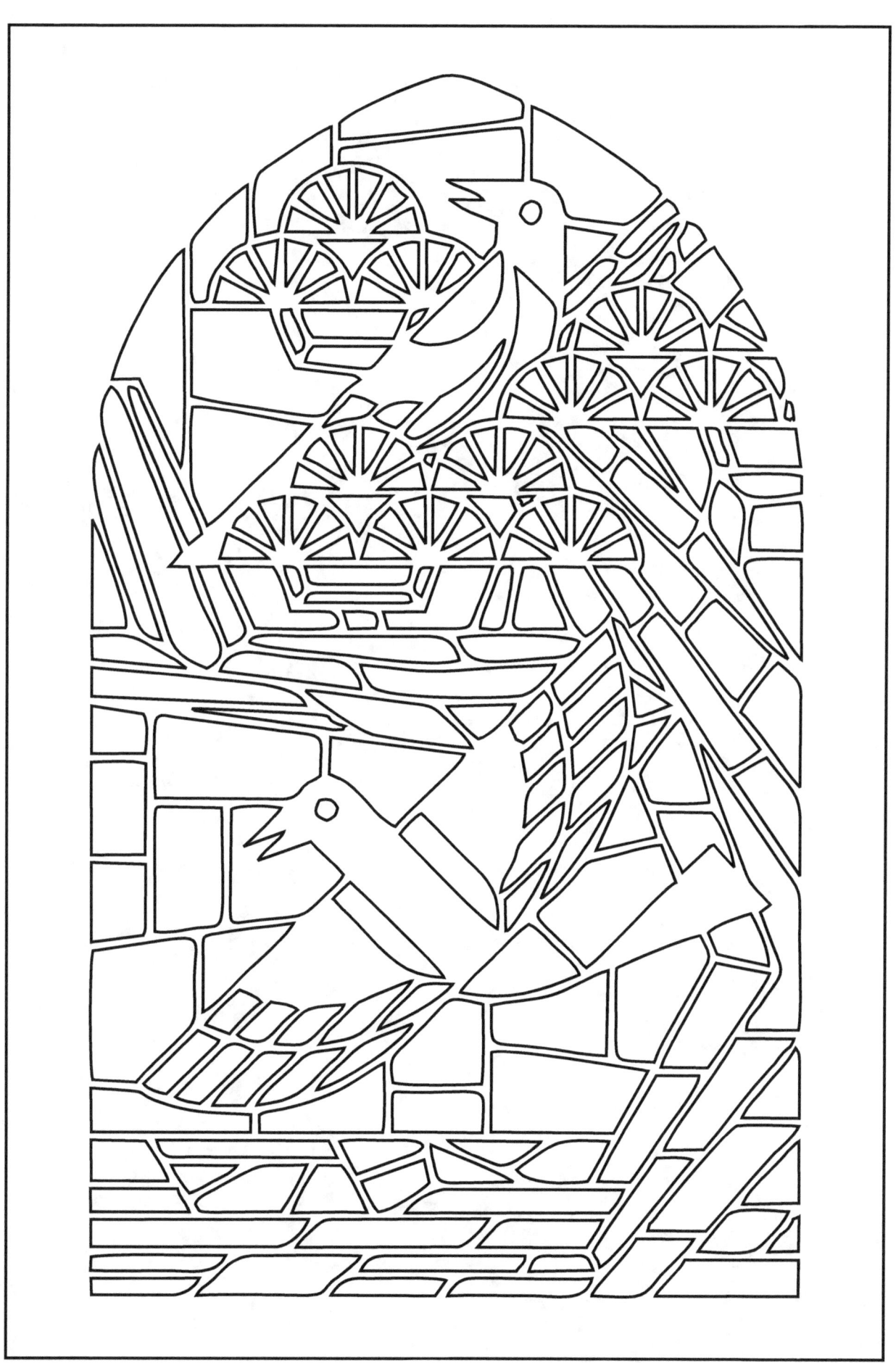

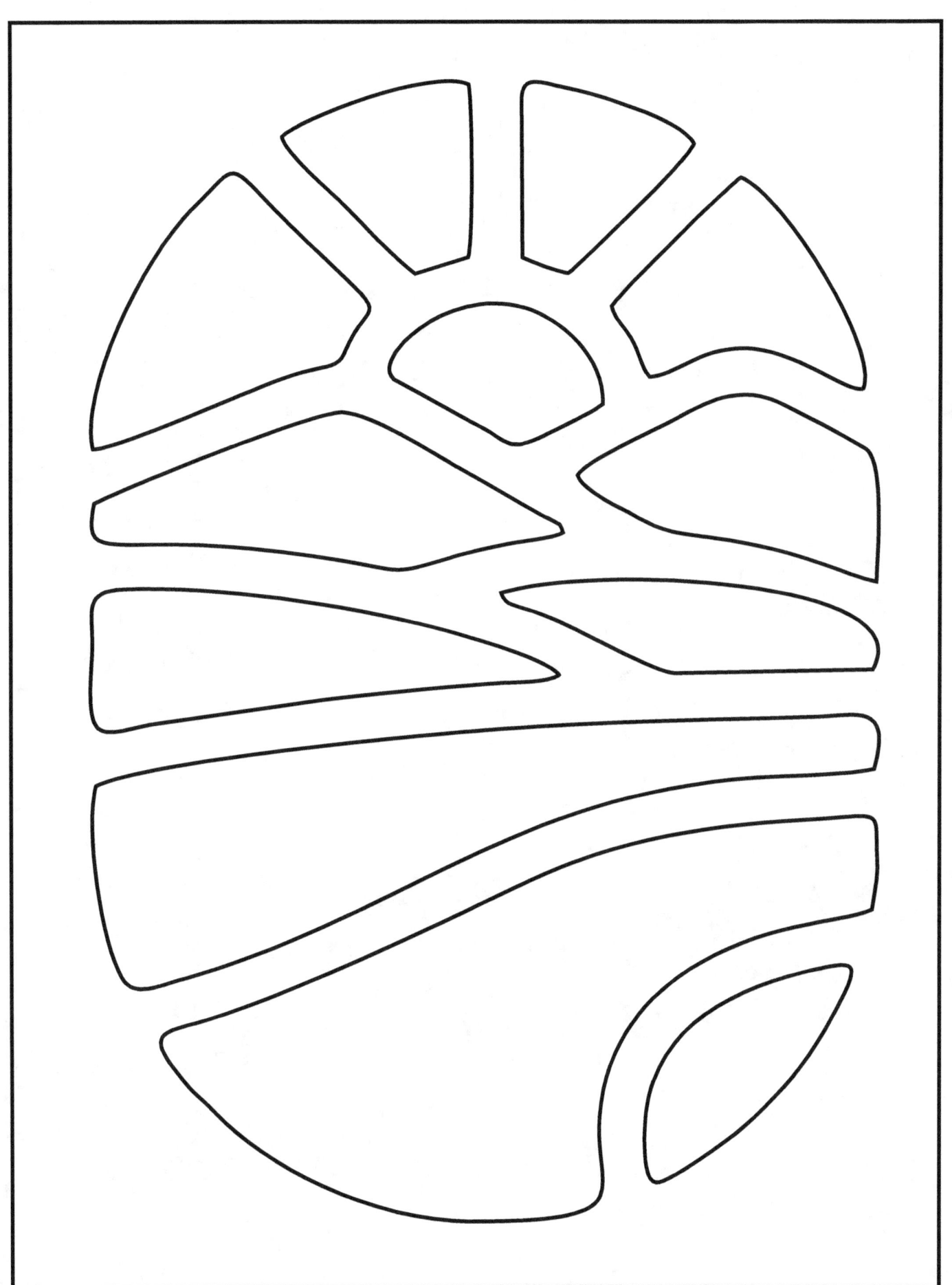

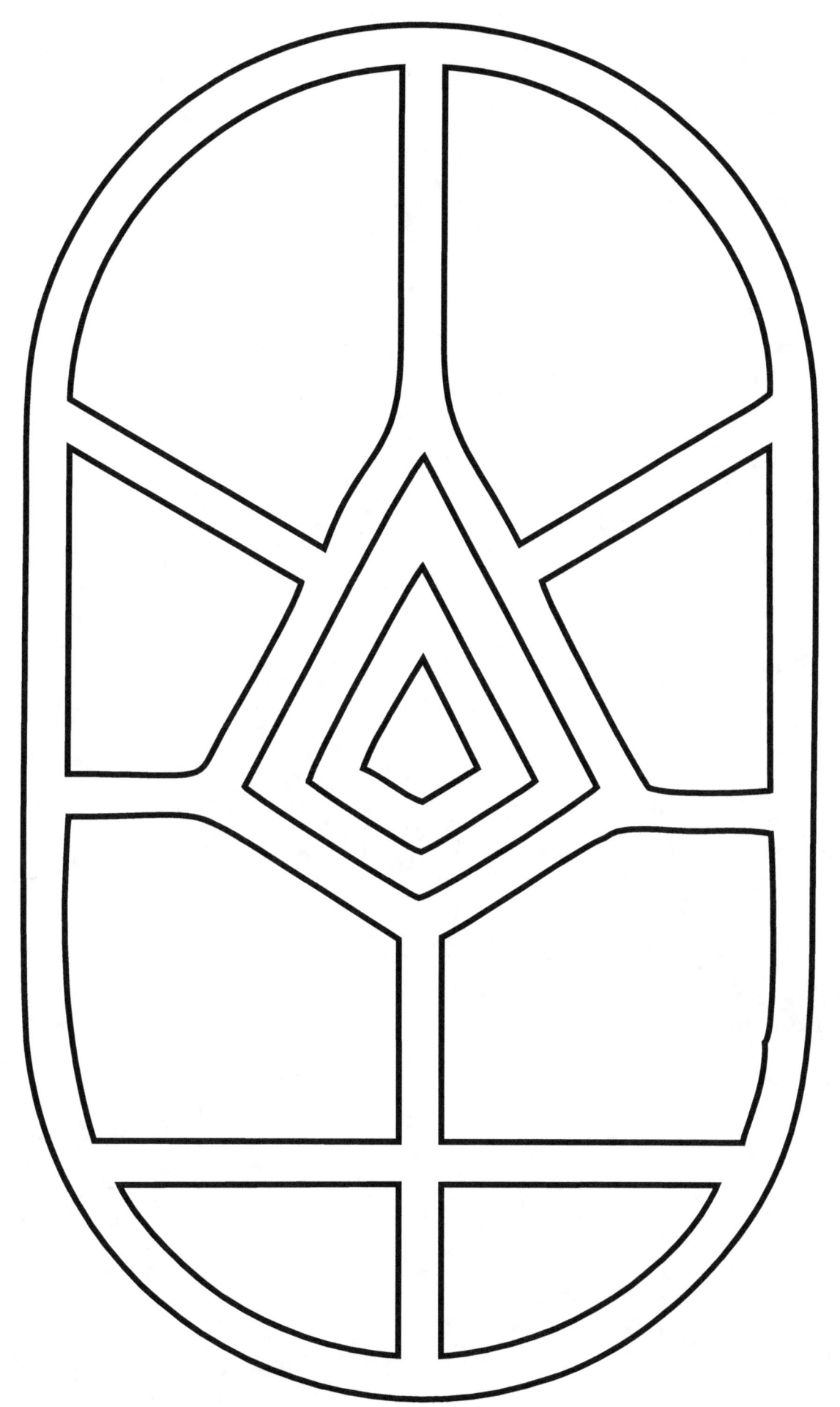

www.ingramcontent.com/pod-product-compliance
Lightning Source LLC
Chambersburg PA
CBHW081457220526
45466CB00008B/2677